CONTENTS.

The higher Rock

The sun in his might

The voice of blood

Christians God's temples

God's witnesses

Christians shining

The raven and the dove

The rainbow

The smoking furnace and burning lamp

The altar of incense

Eating under the juniper-tree

The other side

BIBLE EMBLEMS.

BY
THE LATE REV. EDWARD E. SEELYE, D. D.
SCHENECTADY, N. Y.

BIBLE EMBLEMS.

I.

The higher Rock.

LEAD ME TO THE ROCK THAT IS HIGHER THAN I. Psalm 61:2.

This is a humble cry: the cry of a soul needing help — a soul looking outside of and beyond self for aid and succor.

Strange and unusual as it is to hear it, it is the most rational cry that the human soul ever uttered.

It cannot be disguised, that man is unsatisfied with his present condition. He looks for something higher. He longs to become what he is not now.

Every soul has within it the secret consciousness of imperfection, and a secret aspiration for improvement. Evils and infirmities now encompass it, but it has an idea of a higher state of being, and a more perfect development of spiritual life.

The great question is, how man shall gain this spiritual life. Where is the power which shall effect his elevation and improvement? Where is he to look for that influence which will insure his progress, which will exalt and sanctify him, and fit him to fulfil

the great end of his creation? Is it from earth, or heaven? Is it within him, or above him? Is it human, or divine? Is it nature, or is it grace?

This is the vital question to be settled; the turning-point of all our views of religion and humanity.

We are satisfied that the only basis of man's improvement lies in his dependence upon almighty power. The only rock on which he can ever be satisfied to rest, is the Rock that is higher than he. If ever his condition is bettered, it must be by some agency outside of himself. If ever he is to reach a heaven of perfection and of blessedness, he must be drawn thither by a heavenly power.

We confess we expect very little from all the flattering theories of self-dependence and self-development. We are tired of the endless talk of man's noble and sublime endowments, and his vast capacities for reaching his ultimate perfection. We turn away from much that is uttered under the guise of religion, which is little else than a ringing of perpetual changes on the progressive energy of human nature, and which utterly ignores the need of divine grace, while it teaches man to make himself a seraph. Very empty is it all to us—this godless humanitarianism, discoursing perpetually upon human progress, while it says not a word about man's dependence upon any thing above himself.

It may please the multitude to tell them that they must look solely to themselves for all the resources of a higher life. It tickles the vanity of men to preach to

them of the virtues of self-reliance, and to exhort them with high-sounding oratory to cultivate their manhood, and follow the higher instincts of their nature; to bid them behave worthy of themselves, to find the true law of their being in their own self-hood, and to rely upon the strength of their own spiritual muscle to climb to the higher regions of spiritual perfection. Men love to hear it. They listen readily to the voice of such charmers. It flatters their pride. It deifies their manhood. It gets rid of all those humbling notions of dependence upon God's power. It does away with all such useless exercises as prayer and supplication. It tells men to be true to themselves, to kindle the sparks of their own manhood, and walk in the light of them, while it says nothing of a "Rock which is higher than they."

Grand as such teachings may seem to many, they sound very sad to the Christian: sad, because they are not true; sad, because they are as delusive as they are flattering.

According to all these theories, man is directed to himself for his own salvation and improvement. Nature, and not grace, must save him. He is his own rock on which he must build. He has no object above himself to look to. His god is his own developed humanity. What then is there for him to hold fellowship and communion with higher than himself? What is there to draw him upward; what to excite him to action? How can he rise above his own level? On what ladder will he plant his feet, and what object will attract his gaze and nerve him to exertion?

With nothing outside of himself and above himself to look to, you shut him up to grovel in the dust. Without the law of a higher attraction influencing him, man, with all his ambitious pretensions, will stay where he is. It is only when the sun is in the heavens, scattering its warm beams over the world, that the ocean sends up from its bosom its tribute to the sky. Destroy this solar attraction, and no particle of moisture would rise above the surface.

So the human soul aspires to something above itself, in obedience to the law of spiritual attraction which is beyond itself. Isolate it from God, who is far above it, turn away its thoughts from any rock higher than it, bid it look perpetually inward and never outward and upward, and you have doomed it to despair.

"Is it not strange," remarks the earnest and profound John Foster, "to observe how carefully some philosophers, who deplore the condition of the world and profess to expect its melioration, keep their speculations clear of any idea of Divine interposition? No builders of houses or cities were ever more attentive to guard against the access of flood or fire. If He should but touch their prospective theories of improvement, they would renounce them as defiled, and fit only for vulgar fanaticism. No time is too long to wait, no cost too deep to incur, for the triumph of proving that we have no need of a Divinity regarded as possessing that one attribute which makes it delightful to acknowledge such a Being—the benevolence which would make us happy.

"But even if this noble self-sufficiency cannot be realized, the independence of spirit which has labored for it must not sink at last into piety. This afflicted world, 'this poor terrestrial citadel of man,' is to lock its gates, and keep its miseries, rather than admit the degradation of receiving help from God."

That religion which is taught us in the Bible, is the opposite of all the cruel mockeries of a godless philosophy. It tells of human progress. It bids us hope for a higher life. It cheers us with promises of deliverance and salvation. But it bids us "cease from man, whose breath is in his nostrils," and points us to a Cause above ourselves. It sounds no panegyrics upon our manhood. It talks not of nature's doings, but of grace. It tells us not to trust ourselves, to rely upon our self-hood, but to consent to be helped by a divine power. It leads us not to ourselves, but to "the Rock that is higher" than we.

And in so doing we maintain that the religion of Jesus Christ alone meets the deep-felt want of our souls.

After all the cherished pride of independence, after all the praises sung to "our godlike manhood," after all the strugglings for self-development, the soul feels a consciousness of its weakness, and is burdened with a sense of its own impotency. There are occasions, not a few, when it gives the lie to all the shallow pratings of philosophy, and looks around it for help. It feels its own infirmities. It wants to escape from its loneliness and isolation. It reaches after a power which it does

not possess. It cries for a "Rock which is higher" than it.

The religion of Christ meets this condition of our nature. It tells me I must look beyond myself. It shows me where to look. It reveals to me a Rock, firm, enduring, safe, where I may rest—not in me, but above me, "higher than I"—to which, if I would reach it, I must consent to be led, and to receive aid.

In this school of religion are we taught the lessons of the deepest humility, and the most absolute dependence—lessons such as were never taught in the porch or the grove of refined philosophy. They are opposed to the strongest instincts of our carnal hearts. They extort from the soul the confession of its own helplessness: "Save, Lord, or I perish."

Yet conflicting as true religion is with the pride and self-confidence of carnal man, its provisions and conditions meet precisely the wants of a humble believer. This abnegation of self, and looking away from and above self, is the highest comfort of a Christian's life. This Rock, higher than he, is what he wants to get hold of and lean upon. Lead me to it, is his prayer, uttered from every department of his soul.

1. The *understanding* utters it, when it seeks for knowledge. It asks for a wisdom above its own, to instruct us in the great truths of our being, our relations to God, our duties, and our destiny. It feels that divine wisdom alone is competent to declare what the divine will is.

Men may bid me hear it through the voice of reason; but that cannot satisfy the soul. Like the spider which spins its web from its own bowels and hangs it in the air, have men been long busy in deducing from their own reason their profoundest systems of truth and virtue, and in laying down the rule of duty which would guide them to life eternal. But the result of all such labors has been poor indeed. All the systems which reason has ever framed could never rise above the finite; and multitudes of them have proved but metaphysical cobwebs, entangling the soul which seeks to walk upon them in their perplexing meshes, till, in its strugglings, it breaks through them all, and drops down into the abyss of hopeless scepticism.

I cannot trust my eternal welfare to such deceptive oracles. I want to hear a voice outside of myself to teach me life and duty. I want to hear what God speaks to me, and to believe it because He speaks it. And though in his divine revelation he says many things which are not articulate to my reason, still reason forbids me not to trust in them. Faith lays hold of them, and climbs upward to rest upon "the Rock." Here the Christian soul takes refuge. To the infallible word of God it flies, from all the Babel utterances of rationalistic errors, as its only security, its fortress, and high tower.

2. The human *will* also needs to look above and beyond itself for the Rock of its support.

"There is," says a profound writer, "a sentiment to be found in divers forms among all men, the sentiment

of the need of some external succor, of a support to the human will, of a force which can lend its aid and strength to our necessity."

How true this is every Christian knows by sad experience. "To will is present with me," says Paul, "but how to perform that which is good, I find not."

How changeable our volitions. How many purposes unexecuted lie like wrecks along the shores of our past history. The best of resolutions glow for a time in the soul, but the genial spark thus kindled is soon blown out in the wild tempest of the passions. Our states of mind are variable as the sky. They carry the will along with them. There are tides of human feeling, just as there are tides in the ocean, which ebb and flow in ceaseless agitation. That old Saxon monarch who with his courtiers went down to the shore and issued his command to the ocean surges to go back, till the waves, in mockery of his authority, dashed over his feet, was as successful as he will be, who thinks to subdue with the voice of his own authority the active elements within him, and to subject to the mandates of the human will the troubled sea of thought and feeling in the soul.

Oh, when thus my will is powerless for good, when resolutions strongly framed and guarded go down one by one under the shock of temptation, when thus I climb and fall backwards, repent and sin, and repent again only to resolve anew, then it is I feel the need of something more potent to fix my resolutions and give stability to my purposes. Then it is I wait to hear the

voice of God's authority, and ask to be led to some "Rock higher than I."

3. Again, to such a Rock as this the believer's *affections* naturally aspire. Unless some object more excellent and worthy than self be discovered, then is selfishness the highest virtue. Such an object cannot be found in the creature things which surround us. Magnify them as we may, the soul feels that they are inferior to itself; in all its attempts to love them and go out after them, the soul has a secret consciousness of degradation. It feels that it is stepping downwards and not upwards, when it turns its love upon the material vanities around it. There is, all the while, a suppressed sense of dissatisfaction, a wish and a longing for something better to love, something higher for the heart to reach after.

This feeling in the Christian makes him look upward. God as revealed in Christ is alone sufficient to fill his heart. He discovers the holiness and excellency of his nature. He sees him with all the attributes of divinity and humanity harmoniously blended together, the chief among ten thousands; the one altogether lovely. He feels that he is worthy of his love. He is drawn to him with the cords of love. He is looking higher than self. There is none upon earth he desires besides Him. Now he has found the only object he can safely love. Other things have mocked him: earthly vanities have trifled with his affections; they have betrayed his trust; but Christ fills his heart. He is a higher rock than himself, and he turns thither as his only rest. Lead me to this Rock; let my soul climb here above

the lower level of earth and sense; for here my hope shall not be put to shame.

4. This higher Rock is the only refuge I can find when I feel the need of *pardon and sanctification*. The human conscience testifies of guilt. God's law has been set at naught, and its penalty has been incurred. Justice demands a satisfaction for transgression, else the gate of reconciliation is closed for ever. How can this fearful difficulty be overcome? How can God forgive the guilty? Shut me up to myself, and I am in despair. I could commit the sin myself, but I cannot give the satisfaction. All my present attempts to obedience can have no effect upon what I have done before. My guilt is where I cannot reach it. My prayers and tears and vows cannot wash out the damning record which stands against me. Even could I reform my life and tread in the path of holiness from this time forth, there is guilt already which I cannot cancel.

Oh, the utter helplessness of the soul is one of the most agonizing feelings which attend conviction of sin. Guilt stares me in the face, after all my strugglings. The dark waters go over my head, and I sink for ever, were it not for a rock I can seize hold of, which is Christ a Saviour. The gospel points me to an atonement made for me in the death of Jesus Christ, and bids me look by faith to the sacrifice of the cross. This is precisely what I want.

Oh let me reach this Rock, and I can count over my transgressions without despair; for here the justice of God is satisfied. Here is a full atonement for them all.

Here God smiles upon me with a look of forgiveness, for the law is magnified, and grace abounds. Here is my refuge against all the accusations of conscience and the terrors of guilt. Here on this Rock I rest in peace, a high Rock, above the clouds where the lightning flashes of wrath play and justice hurls the bolts.

Lastly, this divine Rock is the Christian's only support in *the trying calamities of life*. Whatever be their nature, whether temptations, or afflictions, or spiritual distresses, he meets them by looking above and beyond himself for aid.

There is a kind of heroism which the world applauds, exhibited sometimes by men in the trying straits of life, a gloomy heroism which inspires them to breast misfortune with an iron nerve, and "take up arms against a sea of troubles," in firm reliance upon their own indomitable will. It never quails before the face of danger, but will perish in the fierce encounter rather than submit to fear. Often it assumes the form of a grim and sullen stoicism, which sheds no tear over the desolation of cherished hopes, and utters no plaintive cry over the wreck of lost affections. With dogged silence it buries the last of kindred, and at last lies down to die with features cold and mute as marble, and with sealed passports departs to the eternal world.

This, which the world calls manly firmness, is a foul libel on humanity, but a few degrees removed from the sublime stolidity of the brute.

The Christian lays claim to no such heroism, but looks for aid in trouble. He is willing to be helped. From the end of the earth will I cry unto Thee when my heart is overwhelmed, "Lead me to the Rock that is higher than I."

The idea suggested is that of a sufferer struggling in the angry billows; and while he feels his strength rapidly wearing out, he turns his eye in every direction across the boundless waters to find some succor. No friendly sail is seen. Not a spar or plank is left of his shattered vessel. Every thing has gone down beneath the remorseless tide. But yonder looms a solitary rock high in the air. Storms rage about it in vain. The surges dash and roar around its base. The maddened waters are lashed into foam and spray. But there it stands, firm, unmovable, invincible. Heedless of tide and wave and storm, it looks tranquilly out upon the chafed and angry elements, as unconcerned as though naught but sunbeams played and zephyrs whispered.

What that rock is to the wrecked and exhausted mariner who has at length reached its base, and lain down in its friendly clefts, such is Christ to the tossed and troubled believer. In the upheavings of life, when all other trusts have failed, and the waters of affliction are breaking over him, he betakes himself to God, and climbs upon the Rock of ages.

He has no idea of standing on his manhood when distress and death confront him. He is willing to own his dependence, and humbly fly to God for aid. Faith

in God is to him a mightier resource than the boasted iron nerve and proud unconquerable will of nature.

The religion of the Bible teaches us *humility* and *dependence*. Human nature needs help. Human nature must give up its vaporing. Sinners cannot save themselves. If we are ever saved, it must be by looking above, and not within. There is no regenerating power left in the carnal heart. No mere development of the man will ever result in his salvation. There must be an agency *ab extra* to interpose, else we perish. God, not man, must have the glory of our salvation. This is plainly the Bible method; and the sooner we learn to look away from self to something higher, the nearer are we towards attaining it.

Again, the gospel system *meets our wants*, as well as tells us of them. It reveals the Rock higher than we. It points us to a divine Saviour. The same voice which tells us of our necessities, tells us also of the supplies God has furnished to meet them all. Here divine knowledge is given to relieve our doubts, and enlighten our ignorance. Here is divine power tendered to help the feebleness of the will. Here is divine love exhibited to quicken our affections. Here is a divine atonement provided to expiate our guilt. Here is a divine Spirit revealed to sanctify our souls and fit them for heaven and glory. Why all this outlay for those who have ability to take care of themselves? Why such vast provisions for men, if there be yet aught belonging to them which, by mere self-development, can make them holy and meet for

heaven? Why such rich display of grace, if there be any thing left to hope from in mere nature?

It follows that *faith* is the great element of practical religion. "*Believe*, and thou shalt be saved," is the great command and promise of the gospel. Trust in Me for aid; look up to the Rock for a refuge. *Prayer* therefore becomes the vital exercise of a Christian life. It is the soul's outlooking beyond itself; its aspiration after God; the medium through which it receives blessings from its Saviour. For this faith in God is not mere spiritual imbecility, nor torpid helplessness. It is the movement of an earnest soul, awake to its deep necessities, and looking heavenward for help. Prayer is its earnest utterance, its living activity. Lead me upward, is its cry; help me to climb the rock; bear me above temptations which draw me earthward; support me in the conflict which I must meet in my upward way to heaven.

The strength of a Christian's life, paradoxical as it may seem, lies in its dependence. Look up then to the Rock of your salvation. Wait at the throne of grace for aid; wrestle earnestly in prayer, if you would rise above your present level. You are not shut up to nature's resources. You have a higher Rock, where you may build your house. And when the winds of trouble blow, and the floods of death sweep by, your house will stand the shock, and shelter you from harm, for it is founded on a rock.

My dear, yet impenitent friend, our subject tells you what you must come to in order to be saved. You

must quit your hold on self, and consent to look without you for salvation. The sooner you look this fact plainly in the face the better. All your reliance upon your own self-hood, all your boasted progress in virtue, all your godless cultivation of your so called manhood, may be welcome incense offered on the altar of human pride, but they keep you away from the true salvation.

The religion of the Bible is for sinners who need help. Its salvation is for those who are in a lost condition. You must admit this fact, or go without it. If you cannot consent to be saved by interposing grace, you must be left to nature, and the result will be at last, you will not be saved at all. If you will not brook to be told that you are "poor and miserable and blind and naked," and that you must find in Christ Jesus a Rock higher than you, and trust in his atonement to remove your guilt, and pray for the Holy Spirit to wash and sanctify you, then you must do the best you can without a Saviour. You may carry your head up a while, and scorn to be a suppliant; you may plume yourself upon your independence and self-reliance, and ask no favors of God or man; you may disdain to utter a prayer, or a confession; but your glory will be short. Death will soon strip you of your pride, and rob you of your boasting. God will call you to the judgment-seat, and put your manhood to the test.

My dying friend, you cannot keep your present position; you must abandon it ere long. Why not do it now? Why wait till you are driven from it to eternal disgrace, when you may now turn from it, and secure

thereby eternal life? You have got to bow; you have got to pray; you have got to awake to a conviction of your guilt, either now, or in eternity. Why not now — now, when help is near you, and salvation is offered you — now, when the Rock that is higher than you is accessible to you, and you are bidden to hide in its friendly clefts from the gathering storm of Jehovah's wrath?

You may refuse to look upon it now; but not so hereafter. From your deep abyss of gloom your eye will see it far away in the upper world of glory, with the glad companies of the redeemed sitting upon its summit in eternal rest and peace, and singing with the angels. And the spontaneous prayer which would break from your lips, "Lead me to yonder Rock that is higher than I," will be choked and silenced by the awful conviction, that between you and it there is a great gulf fixed, a chasm which no tears can bridge, no prayers can span. Now the Rock is near. The Saviour reaches out his hand. Grasp it, sinner, by faith. Hold on to it and climb to the strong-holds, or you must sink to hell.

II.

The Sun in his Might.

LET THEM THAT LOVE HIM BE AS THE SUN WHEN HE GOETH FORTH IN HIS MIGHT. Judges 5:31.

Thus closes the song of Deborah, the judge and heroine of Israel. Its theme has been the thrilling events of the great battle with Sisera and the Canaanites, the victory of Balak, and the overthrow of Jabin and his hosts. But at its close she rises from the particular event to a general prediction, in the form of a prayer for the destruction of all the enemies of God, and the safety and blessedness of his own people. "So let all thine enemies perish, O Lord; but let them that love him be as the sun when he goeth forth in his might."

"*Them that love him*" is a brief, but most fitting description of true believers, whether Jewish or Christian. Saints are distinguished from others, not only in their relations to God, but in their affections towards him. Reconciled to God through Jesus Christ, they love him with a reverential, obedient, and constant love. Such are, in the highly poetic language of the prophetess, compared to the sun when he goeth forth in his might.

A bold and extravagant figure indeed it appears to us at first view. To liken Christians to the sun may seem presumptuous—the sun, that glorious orb which marshals at his command the planets and satellites that revolve around him—that great central fountain of light and heat, scattering his rays over the vast fields of immensity, imparting light and warmth and vitality throughout his vast territories, and gladdening the numerous tribes of creatures which inhabit them.

But the comparison in the text is specific rather than general. It is to *the going forth* of the sun in his might—to his apparent motion round the earth, produced really by the revolution of the earth upon its axis. The Scriptures employ the language of common life when they describe the phenomena of the natural world.

The going forth of the sun is seen when he rises in glory in the eastern sky, and climbs the heavens in majestic splendor, scattering the mists and gloom of night; when with untiring steps he mounts the zenith, and bends his course along the western slope, till at the close of day he flings aslant over mountaintop and embosomed lake his parting beams, and dips his golden rim behind the horizon, to shine on other lands and gladden their inhabitants.

It is this tireless movement of the sun, this daily progress of the king of day, patrolling as with a giant's tread the ramparts of the skies, that the text employs to illustrate the course of God's people in the world.

Parallel to the text is the passage in Proverbs 4th: "The path of the just is as the shining light, which shineth more and more unto the perfect day." Our subject is then to study the life and experience of the Christian as illustrated by the sun when he goeth forth in his might.

What more sublime and glorious sight can be conceived of than this every-day phenomenon, so common that it is unappreciated and almost unnoticed by the multitudes of busy men—the going forth of the sun in his might? O ye effeminate children of sloth, it is worth snatching a lazy hour from your feverish beds, to rise before the dawn, and watch how the shadows of the night gradually soften and flee away at the approach of the sun-rising, and how the eastern sky lifts her curtains of crimson and gold to welcome his coming. The various tribes of animated creation rejoice on every side. The lark warbles his glad notes, and soars high in the air to catch his first beams.

It is the sun going forth in his might that quickens the life-pulse of nature, and scatters the gloom which enshrouded her. Fresh and joyous as a bridegroom coming out of his chamber, he lifts his head above the hills, and bathes the earth in the splendor of his rays. Shadows retreat through glen and valley to their caves. Breezes gently touch the forest-leaves, and chant their matinee. Placid lakes from their mirrored surface toss back the day-beams. Dew-drops pendent on the flower-petals glisten like diamonds on a vestal's brow. Cascade and cataract with their silvery

spray weave mimic rainbows in his beams. Distant mountains in solemn grandeur lift their tall peaks like golden turrets in the sky; while from jutting promontory and wave-washed beech old ocean peals out her deep, full diapason, and hails the advent of the day. Ah, when I gaze upon a scene like this, I cease to wonder that in other lands, unvisited by the gospel, the Parsee bows and worships the rising sun, and lifts his hands and prays with rapt devotion to the orb of day.

Follow the sun's course from the horizon upward; how, never halting, never wearying, he drives his fire-chariot through the long circuit of the heavens. And when at close of day he bids us a short adieu, it is not with the jaded look of an exhausted courier whose strength is gone, but with the same effulgent countenance that he wore before. Still does he go forth in his *might* when, at evening, from his broad disc he throws with lavish profusion his effulgence over the floating clouds in the vault above, and over hill-top and plain stretched out below.

Would you take the full meaning of the sun's going forth in his *might*, you must bear in mind that this his glorious career is not the phenomenon of a day, but that precisely thus has he fulfilled his mission through weary centuries—that on the generations long forgotten he shone with the same exhaustless splendor; and that since creation's birth, when he was commissioned by the Almighty to rule the day, he has never failed to walk the skies. Centuries have not wearied him; ages have marked no wrinkles on his

brow; but as when the world was new he circled it with light and beauty, so now with the same might does he go forth weariless, changeless.

What is there in this going forth of the sun in his might analogous to the life of the people of God? Where is the point of comparison? How is the moral experience of a Christian to be likened to this going forth of the sun? Unlike the sun, he is not the centre of a mighty system. Unlike the sun, he has no inherent light to scatter around him. Rather like the moon than like the sun does he shine, borrowing all his light from Christ the Sun of righteousness; just as the moon gathers what beams she has from the sun, and reflects them towards us with fainter and more subdued radiance. Like the moon, the Christian shines only when shone upon.

In speaking of Bible imagery, we must beware of straining the figures employed, and forcing upon them an interpretation which is beyond their natural meaning.

The text does not compare the light of the Christian with the light of the sun, but simply the Christian with *the going forth* of the sun.

The analogy then leads us to speak, in the first place, of the *progressive* nature of the Christian's life—his constant upward advancement.

The sun is ever going forth. There is no pause nor cessation to his movements. Tempests and storms sweep over us, and calms succeed; changes and

revolutions mark every thing here on earth, but the sun stops not in his career. His work is never done.

Even so is the Christian life—an onward movement, an advancement step by step in the work of grace.

As Christians, there is no such thing as our standing still, or resting satisfied with our present attainments in knowledge and holiness. It is this onward impulse, this disposition to push forward, this ardent longing for increasing grace, which is one of the strongest evidences that we are truly Christians. Hypocrites and self-deceived ones occasionally are susceptible of religious emotion. Hypocrites may join the church, and stay there till they die, and yet feel no need of progress. But where grace is truly felt, it causes the believer to long for more. The least conformity to the divine image begets a desire for more holiness. It can be satisfied only by awaking in his likeness. "Not as though I had already attained," "I count not myself to have apprehended," is the sentiment of every true Christian soul. "I press towards the mark for the prize of the high calling of God in Christ Jesus," is the fixed purpose of every believer.

The Christian's efforts in grace are not self-exhausting, but self-invigorating. The more he runs, the swifter of foot is he. The duties of yesterday never weary his strength for to-day.

Would you test your piety? then look not back in the distance of years to find the evidences of your salvation. But look at the passing weeks and months, to trace along their history the workings of divine

grace. And Oh, let me warn you that you are trusting in a false and empty hope, unless there be found in your experience a growing conformity to Christ your Saviour, a series of conquests over temptations and besetting sins, a steadier fidelity in Christian duty, a deeper spirituality, a giving way of carnal lusts, a stronger faith, a brighter hope, and a nearer anticipation of heaven and glory. For if you are indeed a Christian, there will be found in you an onward progress in a holy life, a moving forward towards perfection, which will justify us in comparing it to the going forth of the sun.

Again, a Christian life is like the going forth of the sun, inasmuch as it is a progress involving *a mighty power*. The text speaks of the sun going forth in his *might*. The psalmist also describes him, "rejoicing as a strong man to run a race." The apparent motion of the sun daily through the heavens, suggests the idea of almighty power. As if conscious of his strength, he strides like a giant across the sky.

So is the Christian's progress in a holy life one which involves an outlay of exhaustless energies.

He lives through the power of God. His going forth is in the might of the Spirit which upholds him.

When the apostle speaks of "the exceeding greatness of his power to us-ward who believe, according to the working of his mighty power, which he wrought in Christ when he raised him from the dead;" when he talks of "striving according to his working, which worketh in me mightily;" when he, in Ephesians,

attributes his call to the ministry to the effectual working of the power of the grace of God; and when he ascribes glory in the church by Jesus Christ throughout all ages, "unto him that is able to do exceeding abundantly above all that we can ask or think, according to the power *that worketh in us;*" when too the apostle John tells believers that "greater is He that is in you than he that is in the world," do you not perceive that the very sun going forth in his might through the mid-heavens is a spectacle of omnipotence no grander or more sublime than a poor Christian going forth from earth to heaven?

The necessity of this mighty interposition of the divine Spirit arises from the helplessness to which sin has reduced us, and the obstacles to a holy life which beset the Christian.

This power of the Holy Ghost dwells in the believer; first renewing or regenerating him, and then sustaining him. It operates upon his own faculties in such a way that they are called out in earnest effort. Without this power given to us, who of us could stand? We "wrestle not against flesh and blood, but against principalities, against powers, against spiritual wickedness in high places." There is no greater mistake you can fall into than to conceive that a Christian life is a task of feebleness and imbecility. If you would go forth at all, you must advance with a perseverance which never despairs, a vigilance which never slumbers, and a courage which never quails. If you would call yourself a Christian, you must run like the athlete and struggle like the wrestler; for the

believer's course is a powerful movement, like the going forth of the sun in his might.

Faith, the great executive principle of the Christian, is a far different thing from a mere assent to creeds and formulas. It is a *power*, a *mighty power*, quickened in the Christian by the Holy Spirit—a power which moves the will, and controls the lusts, and overcomes the world. Ask yourself, Do you know aught of such a power? Have you felt its workings in your soul? Has grace subdued your passions and fixed your purposes? Has it abased your pride and relaxed your covetousness? Has it worked in you mightily? If not, then has the kingdom of God come to you in word only, not in power.

Again, the sun's going forth is a *joyous* progress. Nothing is more suggestive of joy than the sun shining. His very face is the synonym of gladness. Nature smiles beneath his rays. Lambs skip on the hill-sides, the birds sing gayly, the forests clap their hands.

Fit emblem is the sun's going forth of the healthy development of a Christian life. Gloom and grace are not twin sisters. Joy is a prominent element in genuine experimental religion. "The fruits of the Spirit are love, joy, peace." "Let the righteous be glad," says David; "let them rejoice before God. Yea, let them exceedingly rejoice." "Rejoice in the Lord always;" "rejoice evermore," is the sentiment of the apostle Paul.

The want of this holy joy in your experience is no evidence of your deep piety. Rather is it a proof of a low and imperfect life—a defective faith. Surely it is the Christian, above all others, who should dwell in peace. It is he who can cherish in his bosom a felt sense of God's favor, which is life, and of his loving-kindness, which is better than life. It is he whose soul should walk all day in the light of God's countenance.

But let not this Christian joy be confounded with the boisterous merriment of the ungodly. It is far, very far removed from the mere pleasures of sense. It is not to be sought for in the butterflies of fashion flitting in saloons of gayety, nor in the hoarse laugh of the midnight bacchanalian revel. It is not the silly trifling of brainless fools, who are lovers of pleasure more than lovers of God. But it is the calm, the tranquil joy of the soul at peace with God. Like the joyous sun should the Christian go forth, bright and peaceful, exhibiting in his life that steady hope and cheerful confidence and benignant peace which are as wide apart from the levity and thoughtlessness of the world as they are from the austere gloom of the cloister and the repulsive asceticism of the convent.

Yours is the duty to exhibit to the world a joyous service to your Lord and Saviour. Yours is the privilege to show to your fellow-men that you have found happiness elsewhere than in folly and dissipation, and that there are other pleasures within your reach than the pleasures of sin, which are for a season.

It is important also to observe, that although the life of a real Christian is always progressive, still this progress may not always be *visible* to himself, much less to others. There may be seasons when he can discover no advancement, and when his course is obscured.

It is even so with the going forth of the sun in his might. Every day he makes the circuit of the heavens. He is never stationary. But all days are not the same: clouds sometimes gather; storms and tempests rage above us; the angry elements muster their grim cohorts in the sky; the lightning flashes, the thunders roll; the earth lies shrouded in the drapery of night. Where now is the sun, which a little while ago shone brightly upon us? Has he fled in terror? Has he retreated back, and hid behind the hills above which he rose at morn? No, he has not faltered; far above those clouds, beyond the reach of storm and strife, he still moves on undisturbed. Watch; as the storm subsides, he shows the same bright, joyous face between the opening clouds, and fringes their edges with his golden beams. Yonder he rides in the heavens, just as before. His going forth suffered no interruption when the winds swept and the thunderclouds lowered. True, we could not see him; but when the dark mantle is drawn aside, lo, there he is, undimmed, the same majestic sun, still going forth in his might; and yonder his rays are sporting with the raindrops, and arching the horizon with the rainbow, in whose brilliant colors the Almighty long ago wrote his covenant with the patriarch and with mankind.

So is it with the Christian's progress through the stormy trials and temptations of human life. External circumstances seem sometimes to conspire against him: the tongue of slander may be turned against him; the envenomed shaft of malice may wound his character; his integrity may be suspected, and his good name be cast out as evil; darkness and unbelief may settle upon his own soul; manifold temptations may suddenly surprise him, and he be left to doubt and question whether he be not a castaway: but we are not to conclude that such seasons are all against him. We believe that all the while there may be, there is, progress in such experiences. They are trials which test his faith; they are fires which burn out the corruption which lurks within him.

Although we cannot discern in every case the precise benefit which is to be secured, although we cannot see why God allows some of his dear people to be buffetted continually, yet certain we are that all the temptations which overtake them and the afflictions which weigh upon them are disciplinary in their nature, and are made subservient to their ultimate sanctification. Even in the temporary lapses of the Christian, which surprise and overcome him, there may be the germ of future and higher advancement. Through these he learns his weakness, and is taught the lesson of humility and dependence; and they are followed by a more resolute gathering up of his strength in God, and a more prayerful watchfulness, which give promise of future progress. And accordingly we have often seen the Christian come out of such experience like gold tried in the furnace, a

brighter Christian, a better man, a more chastened, humbled, sanctified believer, for whose good all things are made to work together, according to God's promise. Like the sun's going forth after storms have we seen many a saint emerge from the clouds of adversity, and in later days exhibit a consistency which told that the trials he endured had resulted in good.

Be not discouraged then, Christian, because all days are not alike to you. Think not that there can be no progress when you are encompassed with cares and vexed with temptations. Yield not your confidence when your way seems troubled; for like the sun which goes forth in his might when the elements are astir, so must you keep moving heavenward through the gloom and discouragements of earth.

Such are the Scripture representations of the life of God's own people. It is a progressive life—a powerful and a joyous life—a life advancing and maturing in the face of difficulties.

Compare this, professing Christian, with your actual life. Perhaps you have long professed to love God and to serve him; and what has been your progress? Has the work of grace advanced so that now you can say that you are far beyond your former experience? Can you find in the mastery over temptations, the crucifixion of your lusts, your habitual delight in the word of God and prayer and holy living, and in your indifference to the world, its pleasures and its gains, that you have been moving onward and upward? Oh

then, in your sun-like path, we bid you press eagerly forward unto the perfect day. It is not time yet to relax a single muscle. You cannot halt or loiter.

But are there some with whom it is far otherwise? After living in the church for years, are you just as cold and dormant, just as covetous and worldly as you were years ago? And dare you liken your dwarfed and sickly life to the sun when he goeth forth in his might? Nay, rather must we describe you as a lost pleiad, or one of those "wandering stars" of which Jude speaks, "to which is reserved the blackness of darkness for ever."

Are you growing in grace? If not, you are graceless. If there is no movement, there is no life. If you are a Christian, there is in you a spiritual power of locomotion which will not let you rest. A Christian goes forth like the sun. Once indeed the sun paused at the command of Israel's leader; but there is no Gideon in the world mighty enough to stop the sunlike course of the Christian in the path of grace; nor is there a mount Gibeon to be found where you can bid him stand still.

III.

The Voice of Blood.

AND TO THE BLOOD OF SPRINKLING, THAT SPEAKETH BETTER THINGS THAN THAT OF ABEL. Heb. 12:24.

This is the last entry made in the rich inventory of spiritual blessings which Christians enjoy under the gospel economy. The blood of Christ shed upon the cross is called "the blood of sprinkling," in allusion to the blood of the paschal lamb; or more generally, to the blood of the burnt-offerings which was sprinkled upon and around the altar. The sprinkling of blood was, under the Levitical economy, the symbol of purification, as we are told by the apostle that "almost all things are, by the law, purged with blood."

The text declares that the blood of Christ, shed for sinners, speaks better things than the blood of Abel, which was shed by the murderous hand of his brother, and called for vengeance.

There has always seemed to be a strange, mysterious influence in blood shed by violence. It has a voice mightier than all other voices, which thrills the human soul with awful terror. Once the Almighty spoke in thunder from the blackened brow of Sinai; but generations before and after that, he spoke to men through the medium of blood. This was the language of all the divine sacrifices offered in the remotest times. The instructions of the whole Levitical

economy were written in blood—blood upon the altar, upon the four horns of the altar, upon its sides, around it—ever speaking in language of deep and awful meaning to the worshipper.

Man's blood shed by violence cannot be silenced. It has a cry which rings in the ears, a voice at which all living men start back aghast. It wails like an avenging fiend in the track of murder. It will not keep still. It summons the world to find out the guilty.

The text introduces a contrast between the blood of Christ and that of Abel, or rather, between their utterances. Both spoke, and spoke with mighty power; but their language was far different. In the one it was *terror*, in the other *peace*.

It may be a subject of inquiry, why this distinct and exclusive reference to the blood of Abel, when so many since his time have died by the hands of violence? Every murder speaks, as well as Abel's. The bloody deed committed to-day will publish itself. It is the hardest thing in the world to conceal it. The providence of God often seems to turn the very arts and expedients which were designed to hide it and hush its voice, into the means of its detection. The stone cries out of the wall, and the beam out of the timber answers it. Blood will speak through walls of masonry, through deepest midnight darkness, across seas and deserts uninhabited.

But passing over the many dark calendars of crime which generations had filled up, the apostle singles out Abel alone, as he was the first one of our race who

died, and that by the hand of violence. That murder woke the first cry of blood which the world ever heard. It was when the world was young. And as then there were no human courts established to sit in judgment upon crime and punish the guilty, the Almighty himself came forth from his solitude and made inquisition for blood, and pronounced sentence upon the fratricide. The testimony upon which God convicted Cain, was the testimony of blood. It cried unto heaven from the ground; and by the prompt and terrible interposition of the Almighty at that epoch, God impressed upon the race the sacredness of human life and the certain vengeance which would pursue the man who shed blood.

The blood of Abel, though it spoke a language like to that of ten thousand murders since committed, still arrests attention; for it was the first cry of murder which had shocked the world. It stands at the head of the dark roll of guilt which is still filling up. It stained for the first time the bosom of our mother earth. It flung a ghastly mangled corpse into the first family of our race, and deepened the gloom which, at the fall, settled upon the earliest history of humanity, into shadows black as Tartarus.

These considerations would be enough to prompt the apostle to single out the death of Abel from all that followed it.

And in the text he contrasts its testimony with that of the blood of Christ.

What was its utterance? What did the blood of Abel say? Come with me and stand over the revolting spectacle. Look on the clotted gore and ghastly features of the murdered man, and hear the testimony:

1. The blood of Abel testified to the actual infliction of *the penalty of death* which had been passed upon the race. It is evident that Adam and Eve could not have fully understood the full meaning of the curse which had been pronounced upon them. Spiritual death, consisting in a loss of holiness and separation from God's favor, they had already suffered. And they might have had some vague idea of that death which would close their earthly life, and dissolve the body back to dust; but they could know very little about it. They had never seen it. The death of animals offered in sacrifice would help their conceptions very little. Anxiously they questioned what more there was in the sentence which God had pronounced upon them. Time wore along; their family increased: sons and daughters grew up around them, and yet they had never witnessed an instance of death. Perhaps they began to doubt whether there was any thing more in the curse than what they had already suffered. With ruddy cheeks and growing strength, their posterity increased for more than a century after the fall. Their children's children smiled upon their knees. As yet they had never seen a corpse; as yet the earth had not a single grave.

But from the blood of Abel there came a message of unutterable anguish, which dispelled the faintest

hope of escape from the threatened penalty. Around his body, stretched on the bloody ground, gathered Adam and Eve and their descendants, and there in heartrending agony and distraction gazed on the dead man's ghastly features, and read in them the first lesson of death. Yes, there was death!—death, which they had long talked about, and wondered what it was—death, which they had never seen before: it had come at last.

The awful revelation was before them. All doubt, all questioning about their fatal doom was gone. The king of terrors had entered upon his dominions, and set up his ghostly sceptre over every thing that breathed. There was his first conquest.

And from that blood there went forth a voice which published to all the living the execution of the curse. Henceforth all hope of escape must be cut off. The work of death had now begun. Adam and all his race must prepare to die.

2. The blood of Abel spoke of the deep and awful *depravity* of human nature consequent upon the fall. It showed that man's fallen nature was early ripe for the most atrocious wickedness. The seeds of corruption implanted in that nature required no long period of ages to bring forth their fatal fruits. They developed themselves with most terrible rapidity. The earliest crime on record in the history of the race, is of Titanic proportions. Old as the world has grown in guilt, it has yet found nothing to surpass it. Familiar as we are with its dark and dreary annals, its oft-repeated

chronicles of wickedness, there is not in them all a more thrilling testimony to the deep and universal depravity of fallen nature, than is uttered in that first cry of blood which went up from the ground into the ear of God. It would seem as though man's darkened spirit could not wait for death to begin his fatal work upon the species by what we now call the natural course of sickness and disease, but he must himself chide death with tardiness, and lift his own hand with murderous intent, and slay his fellow.

The blood of Abel speaks not of Abel calmly yielding up his breath, while his head lies peacefully on his mother's lap. It calls us to no softened couch over which fond parents bend in agony, and catch the placid smile which lingers on the countenance, and gather up the few rays of hope which beam in the dying eye, and which seem to whisper that death may, after all, be not so formidable a thing.

In no such way does it speak to us. But it is Abel murdered, Abel stretched upon the cold ground, weltering in his blood, a mangled, ghastly spectacle. And every clotted blade of grass, and every bloody stone has found a tongue, and cries, "A brother's hand has done the hellish deed." We stand aghast, and ask for no more appalling testimony to the total depravity of the species. Try as we may to soften down the hideousness of that depravity, after all our study to find something to relieve the odiousness of that corruption which festers in the soul, there is a voice in the earliest history of the race, a voice of

blood which mocks our arguments and banishes our cherished convictions.

3. The blood of Abel cries for *vengeance*. It was the only testimony the Almighty produced when he summoned Cain to trial. The deed was done in secret. No one saw it. No one heard the dying man's last groan. His lips were sealed, his tongue was stiff and cold, and the murderer thought that by a brazen and persistent denial of his crime, he could escape detection. But though Abel could not testify, and no living man saw the uplifted hand which smote him, still there were witnesses enough. Dumb things grew eloquent, and the voice of blood published the foul deed to God and man.

From what we have read of the history of murderers, it would seem that there was something more than a rhetorical figure in those words in Genesis, which give a voice to the blood shed by violence. Hundreds and thousands have heard such a voice. Often it amounts to nothing, that the assassin has concealed his crime from his fellow-men, and can walk abroad in the community with no suspicious eyes turned towards him. He is haunted by something which keeps publishing his guilt. The ghastly visage of his victim rises before him, and follows him. It shakes its gory locks at him, crossing his path everywhere like an avenger who will not be appeased. Its avenging cry rings in his ears. He starts at the sound of his own footsteps. Every thing seems to echo it. The rustling of a leaf alarms him. The murmuring waterfall tells the bloody tale; the winds wail it through the air. It seems

to him that all the world has found it out. Inanimate things have grown articulate, and published it. He expects the next man who meets him in the street will accuse him to his face. And not unfrequent is it, that by the very alarm and uneasiness, the strange anxiety and restlessness which he betrays, the eye of suspicion is turned upon him, and a clue is furnished, which leads to the disclosure of his crime.

This avenging cry of blood is the hardest thing in the world to silence. It will not be appeased without the life of him who shed it. It is the voice of retributive justice, speaking from the throne of God, and echoed from the inner judgment-seat of the human conscience, demanding blood for blood. It is an awful voice, which, for the first time, the world heard when Abel's blood was shed.

But it is time we turned to listen to another voice to which the text invites us. It is indeed the voice of blood; but it is a strange, a new voice, which speaks a new language to the soul. It is the "blood of sprinkling." The crucifixion of the Son of God was a most foul and atrocious deed of blood: but in consequence of a special and extraordinary arrangement by the Godhead, called the covenant of redemption, that blood spilled on Calvary received a new significancy, and spoke better things than blood had ever spoken before.

1. The blood of sprinkling speaks better things *to God*, than the blood of Abel did. That blood cried unto God from the ground for vengeance, but the blood of

Christ sends aloft to the Almighty's throne a far different testimony. It speaks to God of a full satisfaction made to his law and justice for the sins of guilty men. It stands before the eternal Majesty, and challenges the divine attributes of truth and holiness and justice to say aught they can against the sinner's acquittal and acceptance. It holds up before the glittering sword of justice the cleft side and dripping hands of Jesus, and boldly asks, Is not this enough? It declares to God that now it is consistent with himself and his righteous government to pardon the transgressor, and extend to him the open hand of reconciliation. It pleads for guilty sinners in the heavenly world, and before the throne of Jehovah; and louder than the roll of the eternal anthem, and the shoutings of the angelic choirs, its mighty and prevailing voice is heard, "Spare him; for I have found a ransom." It bids mercy reveal her lovely face, and sway her sceptre over a fallen, but now redeemed world. Yes, the blood of sprinkling is heard in the highest heaven. It speaks in the ear of God.

2. It speaks *to men*. It proclaims to them a new and living way of approach to God. The apostle tells us, in the epistle to the Hebrews, that this way is through the blood of Christ, and that Christ hath consecrated this way to us through the veil, that is to say, his flesh.

Before this new provision was made, the only way of acceptable approach to God was through the covenant of works which required complete personal obedience to the divine law. That way was closed. Sin broke it up, and man had no possible means of

repairing it. Another way must be discovered, else we must remain under condemnation. The blood of sprinkling opens up a new and living way. It speaks to men of pardon, and assures them that the sacrifice of the cross was a full propitiation for their sins, which God himself has approved. It declares to sinners, that now God can be just, and the justifier of the ungodly; that it has done all that was necessary to satisfy divine justice and avert the sentence of wrath which was over them, and that the very God who before appeared to them as a consuming fire, is now plenteous in mercy, and ready to forgive.

3. The blood of Christ speaks peace to the human *conscience*. Anxious as the sinner may be to escape the penalty of his transgressions, his conscience holds him to the conviction that that penalty must be endured; for God, whatever else he be, must be a God of justice, and must insist upon the sanctions of his law. Much as our selfish nature longs to escape suffering for sin, the conscience sternly says it cannot be. That suffering must be met. The penalty of transgression must be borne.

And now comes in the voice of blood, and says it has been borne, for the dying Saviour was made a curse for us. His cruel sufferings were in the stead of ours, and "on him was laid the iniquity of us all." Conscience can now be at rest, for its claims are satisfied. There is peace through the blood of the cross. The sinner may take refuge here from every accusing voice, and cherish the sweet consciousness of forgiveness.

Again, it speaks of *inward cleansing* from pollution. Under the Levitical service, the sprinkling of blood was the symbol of purification. It typified the effects of the blood of Christ. The soul that comes to it experiences an inward renewing, and becomes the seat of gracious affections, implanted by the Holy Spirit.

And lastly, it speaks of final and complete *salvation* in the heavenly world. It is the purchase price of redemption which God the Father has already accepted from Christ his Son. It is all a sinner needs to enter heaven. By it he is fully justified, and adopted into the family of God. It fills the soul with joy and peace, and enables it to hope with confidence for the future glory. It is the believer's title to eternal life, which he can carry with him through the gates of death, and which secures him a joyous welcome to the realms of purity and bliss, whither the Forerunner has already gone to prepare mansions for his people.

Such is the language which the blood of sprinkling speaks. No other blood ever spoke like it. No other voice has borne such tidings of great joy to sinners. Turn your anxious ear to every quarter; go listen to the law; go through the universe and summon all the voices which testify of the Almighty, which bespeak his might and majesty, his wisdom and goodness, and you listen in vain for any utterance of peace and hope and favor to a sinner, like that which is proclaimed in the blood of Calvary. That voice which breaks forth from the cross of Jesus is the apocalypse of the world's redemption.

It is the voice of hope and salvation for a lost and guilty race. It reverberates along the arches of the heavenly world, and calls forth a smile of reconciliation on the face of the Almighty. It rolls over against Sinai, and lo, the dark clouds scatter, and the lightnings cease to flash, and the thunders grow still. It comes to the human soul burdened with guilt and shame, and assures it of pardon, peace, and eternal life.

Thousands upon thousands have heard it, and gone to glory listening to it. It is still speaking. It will keep on speaking till all the dwellers on this earth shall hear it, and an innumerable company out of every kindred and tribe and people shall be saved by it.

I conclude with the solemn words of caution with which the apostle follows up the text: "See that ye refuse not him that speaketh."

There are many calls in the world which we may well refuse to listen to. Many are crying, Lo here, and, Lo there, whom we may refuse to follow. There are many teachings in the various departments of science and history which are interesting and profitable subjects of study; but we may remain in ignorance of them without materially affecting our well being for time or for eternity.

It is not so with this voice which speaks to us in the blood of a crucified Saviour. Here are utterances which it well becomes every man to hear and study. It will not do, sinner, to turn away from it. It is a voice of authority and power. It tells of the inexorable work

of divine justice, of the stern exactions of God's violated law. It tells of an expiation for your sins, of deliverance from the wrath to come. It publishes hope and salvation to the guilty and the lost, pardon and reconciliation with your offended God. It invites you to trust your guilty soul upon the Saviour, to come with godly sorrow for all your transgressions, and accept of God's free grace in a Redeemer. It assures you that your God, against whom you have sinned, is now ready to forgive; that his hand of mercy is reached out to you, and heaven and eternal life are open to you. Oh, hear it; it is the only hope left for you. In all the universe there is no voice like it, which can bring peace and comfort to your soul. Oh, hear it. Though other voices call loudly to you, and importune you; though the world besets you, and business, pleasure, wealth, and honor clamor in your ears; though pride and passion and sinful lusts cry out, and seek to drown its utterances, still turn your ear to the cross, and seek salvation in the atonement which is published there.

For, ah, if you "refuse Him that speaketh," you must perish. You have, in so doing, thrust away from you the only provision which has ever been made to save you from wrath to come. You close behind you the door of reconciliation which the Son of God has opened. You trample under foot the only flag of truce which heaven has sent down to this revolted province. You put an end to all further negotiations for peace, and you rush on the thick bosses of Jehovah's buckler. Oh, pause, we beseech you. Stop before you reject the great salvation. Come and listen

a while to what the blood of Jesus says. Ponder it well before you turn away. Take into account the consequences of its rejection, and see if you can well afford to refuse its blessings.

IV.

Christians God's Temples.

KNOW YE NOT THAT YE ARE THE TEMPLE OF GOD, AND THAT THE SPIRIT OF GOD DWELLETH IN YOU? 1 Cor. 3:16.

The frequency with which the apostles speak of Christians under the figure of a temple, is worthy of special notice. In the sixth chapter of this epistle, Paul calls our bodies the temple of the Holy Ghost. In the second epistle, he calls believers the temple of the living God, in whom God dwells. In Ephesians he describes them as a great building, upon Christ the corner-stone, fitly framed together, growing unto a holy temple in the Lord.

The apostle Peter, also addressing Christians, says, "Ye also, as lively stones, are built up a spiritual house;" and Jude in his epistle exhorts them to build themselves up on their most holy faith, and keep themselves in the love of God.

The figure of a temple was a common and favorite one with the apostles. Two reasons may be assigned for this.

It was easily understood by those whom they addressed. The Christian converts, whether at Corinth, at Philippi, or at Rome, were familiar with these structures. In almost every city of Asia Minor and the whole Roman empire, their massive columns

and lofty domes adorned their streets, and invited them to the worship of the gods. The sacred temple of the true God at Jerusalem also was not unknown to those who were scattered over Asia Minor. Many of the early converts in those parts were of Jewish extraction, and were well acquainted with the temple service at Jerusalem. The figure of a temple was a familiar one, and universally understood by the early Christians.

A second reason for its frequent use in the New Testament is its appropriateness and significancy. The apostles employ it to present Christians in their peculiar position and obligations. It is a most suggestive figure, sometimes applied to Christians individually, at other times to them as a body, the church fitly framed together, and growing unto a holy temple in the Lord.

1. The temples of antiquity were most *costly* structures. Seldom were they erected out of the fortunes of any private individual; the resources of an empire were often spent upon them. The contributions of all the cities of Greece were expended on the famous temple at Delphi; its gorgeous shrines were thickly overlaid with gold, and within its walls were gathered the choicest statuary, and all the combined wonders which art could furnish.

At Rome, the magnificent temple of Jupiter shone with the gilding of more than 12,000 talents, while upon its foundation alone was expended thirty thousand pounds weight of silver.

Ancient Athens exhausted her wealth and the sublimest achievements of art upon those vast and imposing structures built in honor of the gods. The Parthenon, rising in majestic splendor on the brow of the Acropolis, dazzled the eyes of the beholder. Every thoroughfare boasted of some splendid pile. In the age of Pericles, the vast treasures of Greece, the finest marbles from the Parian quarries, the chisel of Phidias and the pencil of Zeuxis, the brass and ivory and gold and ebony and cypress from many lands, were all employed upon those structures which rendered Athens the wonder of the world.

The temple of God at Jerusalem also was built at vast expense. The nation brought their gifts. No private individual was able to construct it.

And are not Christians like the ancient edifices, in the cost which has been incurred in their behalf? Does not the apostle justify this point of comparison when, after saying that our bodies are the temple of the Holy Ghost, he immediately adds, "for ye are bought with a price?" In estimating what it cost to make a human soul, ruined and defiled, into a spiritual temple for God, we cannot enter into any arithmetical calculations of dollars and cents; for says the apostle, "Ye were not redeemed with corruptible things, such as silver and gold." But we must speak of a great expenditure, a mighty outlay which has been incurred. To build the soul's ruins into a temple is a grander, costlier work, than to build the Parthenon. Man could build the latter, but God alone could build the former. And even for him to do it, required a new

and special administration, and the sacrifice of his only Son.

In constructing these spiritual temples, the eternal Son left the realms of glory, and became "a man of sorrows, and acquainted with grief." He was rich, but he became poor, that we, through his poverty, might be rich. To compute the cost of this work, you must take the measure of that infinite sacrifice which the Lord Jesus has made for you: tell what it was to leave the throne of heaven, and become a man on earth; to obey the broken law and bear its curse; to die in agony upon the cross. To compute the cost, you must reckon up the value of that blood which was shed on Calvary, and of the mighty agency of the Holy Spirit which is actually employed in restoring and refitting the human soul.

There is no earthly calculus which can furnish the true answer. There are no corruptible things, such as silver and gold, which can be weighed against the precious blood of the Son of God. Yet this was the price paid for your redemption. This is what these Christian temples cost—temples which the world cares little for, but temples growing beautiful to the eye of God, around whose portals angels hover as ministering spirits, to bear aloft to the throne the prayers which are breathed within them.

2. A temple is remarkable for its *durability*. It is not like a tent, or a tabernacle, pitched for a short season, and then taken down. The materials which are used, and the manner of their construction, show that it will

endure. The temples of antiquity were built for ages. Plutarch, when speaking of those of Athens, says, "Now they are old, they have the freshness of a modern building. A bloom is diffused over them which preserves their aspect untarnished by time, as if they were animated with a spirit of perpetual youth and unfading elegance."

Those sacred structures, so familiar to the early Christians, stood unchanged while generations passed away. Time seemed to pass them by, while men and all their other works mouldered under his touch.

How aptly does this suggest to us the imperishable nature of that work which the Holy Spirit carries on in the temple of the human soul. It is no ephemeral work. Every Christian coworking with God, is working for eternity. That soul which has become a temple, will stand the changes of time, and the floods of temptation. The world cannot demolish it. It is a work of grace. And where God has begun it, he will carry it on to the day of redemption.

The durability of a temple also symbolizes the imperishable nature of the church, the great house which God is building in the world. It shall advance till the world shall end. Other institutions wear out. Colossal edifices of state totter and fall, and the wrecks of mighty dynasties lie strewn along the centuries. But while every thing else grows old, the church of God endures. The great house grows greater; spiritual builders are at work, in our own and

in other lands, quarrying out new stones, and polishing them, and setting them in the walls. Many a time have its enemies battered it, and threatened to lay it in heaps; but the gates of hell have not prevailed against it; it endures; it still rises; column after column is added to it; it will rise till frieze and cornice and arch and dome are finished, and the top-stone shall be set with shoutings of Grace, grace unto it. The church, the great temple of God, shall stand.

3. The temples of antiquity were distinguished by their *beauty of proportion and perfection*. The Greeks and Romans employed the genius of their master artisans and their finest sculptors. All that the highest skill and taste and cultivation could do was profusely lavished on those immortal works of art; and the results produced were those models of architectural strength and symmetry which succeeding ages, with all their boasted progress, have not excelled. Unity of design, the adjustment of many parts in one harmonious whole, each part fitted to its appropriate place, with nothing left out and nothing superfluous, but all united to produce an impression of beauty and harmony on the mind of the beholder — these were the characteristic excellences of those grand old temples to which the apostle compares Christians in our text.

They too are temples in the harmony and proportion of that character which the Holy Ghost builds up within them. Christian character is symmetrical. Like a stately temple, it combines many parts. Faith, love, humility, patience, meekness, hope, endurance, forgiveness, courage, zeal — all these are the materials

which constitute the spiritual edifice. But distinct as they are, they together make one consistent character.

This harmony of the Christian graces is one of the best tests to distinguish true piety from its counterfeits. The want of this is singularly apparent in the bigot or the enthusiast. Such persons generally exhibit a disproportioned, unbalanced character. A few virtues stand out in unnatural prominence, while others seem wanting altogether. A few duties they will perform with the utmost punctiliousness, while others equally essential they never think of. Religion with them becomes identified with some favorite dogma or ism, and tends in that direction to a monstrous development. This distortion of character, this fungus growth in one direction and utter barrenness in others, evinces a want of grace altogether. Such persons are not temples framed by the Holy Ghost. Rather are they like rude, unsightly structures reared by some unskilful hands. Remember, if you are a Christian, you must exhibit the work of religion in your *whole* character. You cannot cultivate one grace at the expense of another. You cannot be all faith and no love; all humility and no self-denial; all zeal and no charity. It is not in that way the Holy Spirit works. The different parts of the spiritual edifice, says Paul, are "fitly framed together," and "grow unto a holy temple in the Lord."

4. Another peculiarity of the temples was, that they were *the property of the deity* to whom they were dedicated. No private individual owned them. Neither kings nor emperors nor the state were their

proprietors; but they were regarded as belonging solely to the gods in whose honor they were built.

And how true is this of Christians, those spiritual temples which God has in the world. The apostle, speaking of the whole church of God, says, He has purchased it with his own blood. And to believers individually he says, "And ye are not your own; for ye are bought with a price." "None of us liveth to himself, and none of us dieth to himself; whether we live therefore, or die, we are the Lord's." A better title in the universe cannot be found than that which Christ has to Christians. He has bought them, ransomed them, redeemed them. They are his absolutely. He is the sole proprietor of these temples. No one else owns them. They do not own themselves. This is your position, my Christian friend. What you are and what you have about you belongs to the Lord Jesus Christ. You owned his right to it all when you professed to be his disciple. Whatever demand is made upon you for your time, your labor, or your property, by him or his cause, you are in duty bound cheerfully to pay. Ye are God's building; ye are God's temple; ye are not your own.

5. The significancy of the figure employed in the text will further appear when we consider the *use* to which a temple is devoted.

A temple was regarded as the dwelling-place of a divinity. The pagan temples had their sacred shrines, attended by priests or vestals, who claimed to repeat the oracle uttered by the gods. In the true temple at

Jerusalem, Jehovah manifested his special presence, and the holy of holies was his dwelling-place. The Christian therefore may well be called a temple; for says the apostle, "The Spirit of God dwelleth in you."

The hearts of many impenitent men are sometimes visited by God's Spirit, as is indicated by the sudden awakenings of conscience; but never is the Spirit said to dwell with them.

Christians are truly temples, as they enjoy the presence of God's Spirit. That presence is manifested not by oracular voices or ecstatic visions. Fanaticism may recite the vagaries of the imagination, and call them new revelations of the Spirit; it may be ever on the look-out for signs and omens, and boast that it can "dream dreams;" but such manifestations are no proof of the indwelling of God's Spirit.

It is not in this way the Bible teaches us that the Spirit of God dwelleth in us; but it points us to the fruits of the Spirit, which are far different. He shows his indwelling by enlightening the believer into the truth. He reveals the things of God to us. He quickens faith in us, and prompts to duty. He fills the soul with peace and joy, by showing us the promises of God's word, and pointing to their certain fulfilment. He guards us against temptation, by quickening us to prayer. He guides us in duty, by pressing upon the conscience the precepts and commands of Christ. In this way does the Holy Spirit give evidence of his presence. In this way he dwells in believers. There may be seasons when the Christian loses the

consciousness of His presence; but He has not departed: even in his backslidings, the Spirit does not forsake him, for the temple where He has dwelt he leaves not to desolation.

Again, the Christian soul is a consecrated temple, a holy place.

Even the pagan temples were consecrated places. They were employed for such rites and observances as were supposed to be acceptable to the deity which dwelt in them. Some of their festivals were scenes of revolting licentiousness, it is true; but they were not displeasing to the divinity they honored, for those divinities themselves were as polluted as their worshippers. Their temples and shrines were as pure as the gods whose name they bore.

The temple of Jehovah, at Jerusalem, was most holy, for Jehovah is the God of holiness. Holiness was enstamped on every stone. "Holiness unto the Lord" was written upon its every apartment. No unclean thing was allowed to cross its sacred threshold. No profane hand was allowed to touch its consecrated vessels. That sacred temple, inhabited by the God of infinite purity, in whose sight the heavens are not clean—that sacred temple whose inner shrine none dare approach but the mitred priest in robes of sanctity and with sacrificial blood, and he but once a year—that temple is a symbol of a true Christian soul—a consecrated, holy soul. This attribute, holiness, is the strong point of comparison. "For the temple of God is holy," says the apostle, "which

temple ye are." Not that the believer attains to immaculate purity in this life, for the New Testament teaches no such doctrine of Christian perfection; but he is holy in that he is a consecrated one, devoted to God's service. Indwelling sin may manifest itself, imperfections may trouble him, but his mind and will are against them. He does not seek them. He does not go out to drag any polluted thing within the temple. No, he hates their presence; he longs and prays to be free from sin. Whatever imperfections are within him are the remains of former corruptions, and grace is overcoming them.

We must bear in mind that this spiritual temple is not new in its material parts. It is an old, ruined, dilapidated temple, rebuilt, repaired, cleansed, and reinhabited. The devil, who before held it, has been banished. The Holy Ghost has taken possession, and set it apart for God. Yet some vestiges of its old state linger here and there for a time; the divine Architect has not yet finished it. When it is done, it will be pure as heaven, and shine in the beauty of holiness for ever and ever. The work is going on.

The Christian is no longer a sinner, courting sin; he is set apart for a sacred use; he is taken away from the service of sin; the world has no right to him; he has no right to go after it. Oh it is not every use you can put a Christian to, for he is devoted to the service of God; he is called into holiness; he is washed and sanctified.

And now, in the review of our subject, let us walk about these living temples and notice their most prominent peculiarities, that we may see what manner of persons we ought to be in all holy conversation and doctrine.

As temples, they are costly edifices, bought with the blood of Jesus Christ. They are enduring, built to stand the temptations of time, to survive the wreck and conflagration of the last day. They are beautiful in their proportions, with no heavenly grace left out, and no foul deformities suffered to remain. They belong to God. They are not their own. They are God's building. They are the dwelling-places of God's Spirit. They are holy: washed, sanctified, and consecrated to God's service.

Such is the picture of God's people which the apostle holds up before us when he says, "Ye are the temple of God." I confess it is a bold and highly-drawn picture; but it was the pencil of inspiration, and not mine, which drew it. The soul of every true saint is that temple. It has a holy of holies where God's Spirit dwells. The world, the flesh, and the devil have been cast out. It has an altar on which the sacrifice of thanksgiving is laid, a censer in which burns the incense of prayer, which rolls aloft to heaven, while the voice of praise and adoration echoes through its arches and along its aisles.

Sublime and beautiful picture! Is it a fancy piece; or is it a reality? It is a reality. The apostle's soul was such a temple. There were such temples in Corinth when

he wrote this epistle—temples more grand and beautiful than all the Corinthian columns and gilded domes which adorned that city. Every true saint is such a temple. Every professor of religion claims to be one.

My friend, take the picture home, and look at it. Study it well, and see if you can see yourself in it. Ah, you professing Christian, does your soul look any thing like it? If indeed it be a temple, does it not become you to watch its portals with untiring vigilance, lest pollution enter it? Have you kept the temple pure? Our text calls you to serious self-examination. Go inside the temple, and look about. See if its walls be not hung round with pictures of earthly idolatry. See whether pride and vanity and fashion have not built their altars within. See whether greedy avarice has not set up the tables of the money-changers there, and well-nigh turned the temple of the soul, which is God's house, into a house of merchandise. Listen whether there is heard there the tumult of angry passions, and the clamors of selfish and forbidden lusts.

Oh search the temple well, for God will search it soon. "The Lord shall suddenly come to his temple; but who may abide the day of his coming, and who shall stand when he appeareth? For he is like a refiner's fire, and like fuller's soap."

None but the pure in heart, the sanctified in Christ Jesus, will endure the trial. These shall stand the fires

of the judgment-day, and shine in bliss and glory for ever in the city of God.

But not a few professed temple-builders will be confounded, and their work consumed; for the fire shall try every man's work, of what sort it is.

V.

God's Witnesses.

YE ARE MY WITNESSES. Isa. 43:10.

There is a sense in which all the works of God declare his glory, and bespeak his eternal power and godhead. But in the work of redemption through Jesus Christ his Son, he places his people in a peculiar position, and employs them in a special mission. They are surrounded with a world of ungodliness and impenitence, and he has commissioned them to bear an authoritative testimony in behalf of Him.

As professed believers, they stand before the world as those who are the subjects of his grace, who have embraced and tried that religion which is offered to them in Christ Jesus. They claim to have actually received Christ, and to have submitted to his authority. God calls them his people; they call themselves so. In them grace exhibits what it can do by what it is already doing.

They hold a peculiar relation to a godless world around them. God acknowledges them to be standing for him: "Ye are my witnesses." They are bearing testimony in his behalf before the jury, consisting of the multitude of unbelievers. They are credible witnesses. The world is willing to listen to their evidence, and judge of the religion of Christ by what they say and do.

They represent the Saviour whose name they bear. They are speaking to the world in all they say and do, wherever they go. They are always on the stand giving in their testimony. The ungodly world is listening to them, and taking down the evidence, and judging of Christ and of his religion by the declarations which they make; and they have a right to do so.

God says of these professing Christians, "Ye are my witnesses." And other men say, We will hear you and take your testimony, and cross-examine you, and give our verdict from what you declare to us. Every Christian, by his very profession of religion, puts himself in this solemn position, and invites the scrutiny of the world. He cannot escape from it. He must testify for God, and woe be to him if in his life and conversation he belies his profession, and dishonors his Saviour's cause.

God has a testimony of himself in his written word. But this documentary evidence will not satisfy an unbelieving generation. Men want parol evidence to confirm it. They call for the living witness, and insist upon examining him and hearing him give in his testimony. Professing Christians are such witnesses. And what they say in their lives and professions is often of far greater weight with the ungodly, than what is said by inspired evangelists and apostles. This living testimony of God's people is a kind of evidence which carries conviction with it. The Bible itself points men to it, and tells them to decide by it upon the value of its own utterances. "Ye are my witnesses,"

saith God. "Ye are our epistle," says the inspired apostle. The world will take knowledge of them that they have been with Jesus.

All parties concerned seem to agree upon the important position the people of God occupy in this world. God expressly declares that they are his witnesses. They say the same when they openly profess his name. They take the stand before the jury of the world, and raise their hand to heaven and swear that they will testify for Christ. The world looks on, and says, We will hear the testimony, and judge of what religion is, and what is the genius and spirit of the gospel system of salvation by what we find in them.

The case then seems fairly opened, and all parties understand the issue. Let us look further at the nature of the evidence.

1. Believers are Christ's witnesses as to *the real value and efficacy* of that salvation which the gospel offers. As it is presented in God's word, it claims to be effectual in taking away the curse of sin, and in bringing the sinner back to peace and reconciliation with God. It claims to quiet the fears of a guilty conscience, to awaken a sense of pardon and good hope of eternal life, and to furnish, in the atonement and death of Jesus Christ the Saviour, all that the guilty soul needs for its justification and peace with God.

But does it do this? Can it really accomplish in the soul of a sinner this which it claims to do? Does it

ever actually produce such a change of feeling, awaken such hopes, restore such peace, as it tells about? On this subject, believers are important witnesses. They profess to have tried the efficacy of these representations in their own experience. They tell the ungodly they have found this sense of pardon, have felt this peace, have rejoiced in those hopes which the gospel speaks of. They have come to Christ as the atoning sacrifice, and he has proved himself to be to them all he claimed to be.

The work of grace in the hearts of Christians is such, that they can tell sinners what it is. They declare it in their songs of praise, their thanksgivings and prayers, and earnest love to their Redeemer.

2. Professing Christians are witnesses to the world as to what that *standard of morality* is, which the precepts of the gospel require of its followers. They profess to live according to that standard. They have taken the commands of Christ to be their rule of duty, and they virtually tell others to judge of what the religion of Jesus Christ requires, by the way they live and act. They have undertaken to give a practical exhibition of what is the meaning of those Bible directions which comprise the sum of religious duty. The question with them is not what the world thinks to be right or wrong, not what public opinion approves or disapproves; but what does Christ command. This is their rule of duty; this is what they profess to live by. And the world understand it so. They therefore take what they find in Christians' lives and conduct to be what religion consists in. They care not to search for

the letter of the precept in the Scriptures, so long as they have the living witness before them, who says he is showing it to them every day.

Christians are such witnesses. They may well tremble at their position. But they have placed themselves in it. They have undertaken to be witnesses for Christ. Oh, it becomes them to be careful what they are saying. It becomes them to inquire what idea the world gets of Christ and his religion, from the way they carry themselves among their neighbors.

Every one knows that example is more powerful than precept. Every professing Christian's example directly involves in it the honor of Christ, and the welfare of his cause. It is competent evidence, and the world takes it. That professor who lives in violation of Christ's commands, and by his example approves what the religion of the gospel forbids, is a perjured witness on the stand, and gives a false testimony.

That Christians are thus expounders of the gospel, witnesses as to what are the duties it enjoins, and what constitutes practical religion, none can deny. The impenitent take them to be such. Whatever Christians do, they say must be right. Whatever the church practices and countenances, is a sufficient justification for them in doing the same. Whatever is done in the green tree, can certainly be done in the dry.

If God's people can travel and visit on the Sabbath, or engage in promiscuous dancing and card-playing in the nightly assemblies of amusement and frivolity, or

resort to the gamester's arts to make money for Christ, surely such practices cannot be wrong for others; for Christians would not do wrong, nor deny their principles. The world reason in this way, and they reason well. The logic is good, and cannot be refuted. They have a right to take notice of Christians as God's witnesses, and to infer that whatever they do is consistent with the morality of the New Testament.

3. Christians are witnesses to the world as to what are the *sacrifices and self-denials* which the religion of Christ requires of its disciples. That the gospel does make these a condition of discipleship is plain to every mind. Whosoever doth not "deny himself, and take up his cross," cannot be my disciple. Again and again are Christians said to sacrifice all for Christ, and to be crucified to the world. Now what these Scripture representations mean may be learned by the practical lives of God's people, for they profess to be living such lives of self-denial, to deny ungodliness and worldly lust, and to live soberly, righteously, and godly in this present world. In them the impenitent find what religion prohibits; how it separates its follower from the world; how it lays its cross upon him, and calls upon him to bear reproach and shame and wrong and persecution for Christ's sake. Such a testimony Christians are bound to give; and blessed be God, they have been able to give it in all ages of the world. For,

They are God's witnesses in their *endurance of suffering* for Christ. Even when laid aside from the active, stirring duties of life, and passing through seasons of

sore trial, they are still in the service of Christ, and giving to the world a most valuable testimony of the sustaining and comforting power of his religion. Witness-bearers they are still, when they endure with a cheerful patience the wearisome nights which are appointed to them, and in the midst of disease and the sinkings of nature can tell to all around them of a peace which passeth all understanding, of a joy and hope which are undimmed by all the distress of the present hour. Who can measure the influence which the religion of Christ has gained in the world through this kind of testimony?—a testimony which the witnesses have given in when their eyes were suffused with tears, and earthly misfortunes pressed sore upon them—a testimony plaintively whispered in the dark midnight of affliction, from the couches of languishing, the chambers of bereavement, and the graves of the lost and the loved. It many a time seems that the Christian's usefulness is gone, when he is no longer able to sing in the sanctuary and engage in active labors for Christ; but it is often far otherwise. Though life's scenes be changed, he is bearing witness still; and through months of infirmity and suffering is telling the world what Christ can do to cheer and comfort when all other comfort is gone. "Ye are still my witnesses," says the Redeemer to his people, "even when I chasten you sorely; and through your testimony the world shall know of my power to save and comfort."

But though all the sufferings of God's people are made to testify of the power of His grace, special significance attaches to those which are endured

directly for Christ, which arise from the hatred and persecution of the world. Of those who, in past ages, have sealed their testimony with their blood, who in the dungeon, at the stake, and on the scaffold have owned Christ and defied the rage of their tormentors—of such emphatically Christ says, "Ye are my witnesses." The very word martyr signifies a witness, in the Greek language.

And the testimony of such as have suffered and died for Jesus has carried with it a power which none can measure. It has forced conviction on the minds of the bitterest enemies of the cross, and taught the world how a believer can triumph over suffering, and conquer death. Though nowadays but little of this kind of testimony is heard, except what is echoed down from past centuries of the church's conflicts, still believers are bound to testify many times against the scoffs and opposition of the ungodly. Their lives and example must, even now, frequently speak out boldly against the prevailing iniquity, and testify in the face of scorn and loss and bitter opposition. But it is a good confession when you stand up for Christ, and meet the buffetings of the world for it. For every stripe you receive there seems to come an echo from the upper throne, most cheering, "Ye are my witnesses."

We have thus endeavored to show the position which Christians occupy in the world as witnesses for God. They testify to men what the religion of the gospel actually means, what it is, and what it can do for sinners. They tell to a doubting world that it is a

reality. They have tested it in their experience; have tried its hopes and promises, and tasted its saving power. The ignorant and unbelieving world can go to them and ask questions, examine them, and demand to know all about the cross, and the whole system of salvation which centres there.

These witnesses are speaking all the time. Their lives are voiceful everywhere. In the family, and in the church; in the marts of business, and the intercourse of social life; in the days of sunshine and prosperity, and the nights of gloom and sorrow, the world is listening to what they say, and canvassing their evidence. Their testimony is long and full. It is either for or against their Master.

Christ Jesus is willing that his religion shall be tried by the lives of his disciples. What other system will bear to be put to such a test? Did scepticism ever proclaim its triumphs thus? Did the philosophic infidelity of the last century dare to boast of France redeemed from superstition under the reign of terror, and point to Danton, Mirabeau, Robespierre, and the heroes of the guillotine, and say, These are my witnesses? Would Paine and Bolingbroke ever think of summoning from the foul attics and purlieus of vice and degradation their begrimed followers, educated in their tenets, and proclaim to the world, Behold, these are our witnesses? Does Universalism ever muster its motley crew from the dram-shops, the gambling hells, and the brothels, and parade them before the public gaze to testify what it can do for man's moral welfare and restoration? No. Every

system of falsehood and error shrinks from the ordeal, and would hide its disciples from observation, rather than stand them up before the world, saying, These are my witnesses.

But Christianity dares to do what no other system dares. God has written his great scheme of salvation on the page of revelation. But while a doubting, unbelieving world is slow to study and receive it, he sets his people boldly up before them, and challenges them to read in their lives and doings what his religion can accomplish. Look here, he bids an ungodly world, and judge what the cross can do. Trace the influence of the gospel upon these who have accepted it, and tried it, and hear what they are saying of its power and grace; for they are my witnesses, saith the Lord.

Such is the Christian's attitude before the world: testifying every hour, speaking through all his life for Christ. Oh what a blessed, an exalted privilege! Oh what an awful responsibility! Every member of the church is in this position; every professing Christian is testifying. And, fellow-witnesses, what is the testimony we are giving? Are any disposed to shrink back from the position? Are any conscious that their lives do not read well for Christ? There is no escaping from the responsibility. Ye who have made a profession of Christ before the world are committed. Ye have taken the witness-stand, and the world is hearing you. Professing Christians, the voice of God Almighty says, "Ye are my witnesses," and there is no escape for you. You have spoken; you have got to

speak. You may seal up your lips, but your very silence speaks. "Ye are my witnesses."

Hear it, ye professors, when ye go out into the world of ungodliness; when ye stand in the market-place for gain, and deal with a world of covetousness and greed; when ye seek for pleasure and preferment: "Ye are my witnesses." Hear it when tempted to step aside and hold your religion in abeyance for a season, that you may join hands with the careless and the vain: "Ye are my witnesses." Ye cannot drop your vocation; ye cannot stop the testimony. Go where you will, it follows you. Was your hoarse laugh heard in the saloon, among the fast young men whose eyes were red over the wine-cup? Were ye seen in the companies of fashion and dissipation, whirling in the dance, rattling the dice, or bending over the card-table? Have ye forsaken the services of devotion, the sanctuary, and the prayer-meeting, for the society of open worldliness and ungodliness? Ye have not done testifying yet. God Almighty's voice follows you, and rings in your ears, "Ye are my witnesses." Your testimony may have been dishonoring to God; it may have been damaging to the cause of Christ; but God claims you as his witnesses, and will settle with you when he comes to review the testimony at the judgment-day. And your false, treacherous souls, blackened with the damning guilt of a life-long perjury, will meet a doom which will make the hell of lesser sinners, when compared with it, seem almost a heaven.

VI.

Christians Shining.

LET YOUR LIGHT SO SHINE BEFORE MEN, THAT THEY MAY SEE YOUR GOOD WORKS, AND GLORIFY YOUR FATHER WHICH IS IN HEAVEN. Matt. 5:16.

The people of God are the light of the world—luminous bodies, shining amid the moral darkness around them.

Two kinds of bodies, in the physical world, are mediums of light. Those which are in their very substance luminous, as the sun, the fixed stars, or a burning lamp. These shine by virtue of their own properties. Their light is inherent and underived. Another class of bodies shine only by reflected light. Opaque in their nature, they send back only those rays which are sent upon them. Such are the moon, the planets and their satellites—luminous only upon the surface, but dark within.

In a certain degree, Christians resemble this latter class of bodies; but not altogether. The light they possess is indeed a derived light, and not self-originated. They are by nature dark and rayless; but the light which has shone upon them penetrates beyond the surface, and makes the very inner soul luminous with its radiance. It generates light: it transforms them into living light-bearers. They not only reflect the beams which fall upon the surface, but

send forth from within new rays of moral brightness. "God," says the apostle, "who commanded the light to shine out of darkness, hath shined in our hearts, to give the light of the knowledge of the glory of God in the face of Jesus Christ."

Christians, then, are not mere reflectors, luminous only on the surface; but they radiate light from their own inner being. This light is owing to the illuminating power of the Holy Spirit, awakening, converting, and sanctifying them. By that power they are made in the image of Christ, and saved. Such is the light they possess—a light enkindled within them, and reflected from them.

Our Saviour teaches, in the text, that this light which they have *must shine through their practical lives and conduct*. "Let your light so shine before men, that they may see your good works, and glorify your Father which is in heaven." It is the very nature of light to shine. Christians shine through their holy lives. Their good works are the rays which they emit. The world sees them, and judges of them. In all they say and do for God, in the spirit which they manifest, and the example they exhibit, they scatter light around them. Other men see it.

The tendency of this is to prompt others to glorify God the Father—"that they, seeing your good works, may glorify your Father which is in heaven." This too must be the motive to prompt Christians to diligence in good works. It is not to exalt themselves, but to honor God. Not to establish a ground of merit in the

sight of God, not to build up a righteousness of their own, do they strive for a holy life, but to glorify God. Not to shine and bedazzle others by the splendor of their virtue; but to shed around them that light which they have received, to reflect the beams which have illuminated them, and thereby lead others to praise and glorify God for his wondrous work of grace in them.

Hence we derive the proposition that God's people, redeemed by the blood of Christ, and regenerated by the Holy Spirit, *are shining ones*, exhibiting the glory of God, beyond any other of his creatures or works.

In illustrating this proposition I remark, that God is revealed to us only through his works. "No man hath seen God at any time." Purely spiritual in his nature, and infinite in his perfections, we cannot know him, except through his works. How he is known to angels and the pure spirits of heaven, we cannot tell; but to us, the Lord is known by the operation of his hands. His character and glory are reflected to us by his doings. Yet the different works of God manifest to us his glory in different degrees, according to their nature.

1. His material creation exhibits to us his omnipotence, his wisdom, skill, and greatness. When we cast our eyes upward and view the boundless fields of immensity studded with suns and satellites, sweeping the trackless territories of space with no discord or confusion, and then turn our eye earthward and survey the infinite variety of material

objects around us, with properties varying endlessly, and yet all combined in one beautiful and harmonious whole, our minds cannot resist the impression of the might, the grandeur, the magnificence of Deity. Here we behold his glory as the great Architect, the omnipotent Creator.

2. But when we advance from mere lifeless matter to his doings with living, sentient creatures, who are capable of enjoyment and of suffering, these exhibit his glory in a higher perfection than any material handiwork; for here appears the goodness and benevolence of God, seen in the constitution of these creatures for happiness, and the abundant means which he has provided for their well-being. In moulding and shaping the material universe into an infinite variety of forms, God publishes his glory as a skilful and mighty builder; but when he comes to people these material worlds with sentient creatures, and displays an adaptation of all to promote their enjoyment, then does the Deity rise far above the place of a mere architectural designer, and proclaim his kindness and his love. The irrational creation, from the summer insect which sports out its brief existence in the sunbeams, to the flocks and herds which range the valleys clothed with verdure, all unite their testimony that God is good, and his tender mercies are over all his works.

Ascend now a step higher. Follow up the scale of being from mere sentient, irrational creatures, to moral, responsible intelligences. Here is reflected a new class of the Creator's attributes. Here there shines

a glory which the whole material universe never could reveal. In creating and dealing with moral agents, endowed with reason and moral sense, the Almighty manifests the truth, the justice, and the holiness of his character. These glorious perfections of God rise infinitely above his mere natural attributes; and they require creatures endowed with a moral nature, and under a moral government, in order to their manifestation. God might build worlds upon worlds, and deck them with far more gorgeous splendors than are flung over this one we live on; but were they unpeopled by any rational intelligences, they could publish nothing of God's glory, except that he was a builder of mighty power and skill. This is what Nature, in her works, declares of God. But when God calls into being his moral creation, he advances far beyond the position of a mere architect, an almighty builder, to that of a moral governor; and in the unfoldings of his character we discover what we never could see elsewhere, the beauty of holiness, the majesty of justice, the excellency of truth.

These lofty perfections of the divine nature are reflected in His dealings with moral beings, and nowhere else. In rewarding holiness, and punishing transgression, Jehovah exhibits the transcendent purity of his own being. Holy angels in their raptures, and fallen angels in their woes, reflect the moral glory of the Godhead. In dealing with them, God publishes to the universe his supreme regard for his holy law, and that "righteousness and judgment are the habitation of his throne."

Is there any higher glory than this possible? Are there any perfections of God back of these which wait to be revealed; any grander purposes and movements of the divine mind which can enhance the lustre of his character, and add to the splendor of that "light, inaccessible, and full of glory," which surrounds his dwelling-place? Yes, there are.

It is in his relations and dealings with *redeemed men*, in saving sinners, and restoring them from a fallen, ruined state, to holiness and bliss. Here is a new glory thrown around his character, a new theatre of action. Here the divine mind grapples with the great problem of moral evil, and proposes to save the sinner without compromising His truth and holiness. Here the perfections of love and mercy, compassion and forbearance, favor to the wretched, grace to the undeserving, all break forth.

These perfections of God's nature could never have been known to his intelligent universe without a plan of salvation for sinners. The angels in the realms of holiness never could have called them into exercise. Much as God might delight to reward and bless them, he could not show aught of compassion or grace to them, for there could be no possible room for God to exercise any such dispositions towards such beings. Mercy can be exercised only towards the wretched, grace only to the unworthy, long-suffering and forbearance only towards the guilty; but in the case of holy beings, God can find nothing to forgive, nothing to bear with, nothing to develop the riches of his grace.

We see then, how redeemed sinners exhibit the glory of God in a strange and peculiar light. When God moves to save them, he displays a new class of perfections, which never could be known except as they are here manifested. Every Christian is a living epistle, publishing something of God which the intelligent universe can read nowhere else. Every Christian declares that God is a God of infinite grace and mercy, long-suffering and forgiving; a God full of compassion and love. He is a living witness to these perfections, for he is a guilty creature rescued from sin and hell. In him God displays precisely those traits of his character which awaken the profoundest admiration of his creatures, which attract them towards him, which enkindle love. Indeed we may say that, were it not for the plan of salvation for sinners, there would exist in the divine nature a class of perfections of which his creatures must be for ever ignorant.

But this plan lifts the veil, and bids us behold the infinite heart of God. The Christian is the being in whom God displays these excellences; he is the trophy of grace; he reflects the glory of the Godhead beyond any thing seen in all other creatures. None but he can testify of Jehovah's boundless grace and compassion, of the triumph of infinite wisdom and love in baffling the arts of Satan, and rescuing a lost sinner from hell and fitting him for heaven. This work is the climax of Jehovah's undertakings, and the Bible plainly teaches that to angelic minds there are no operations of the Godhead, throughout his vast

dominions, which can compare with this in interest and in glory.

Again, as has been already remarked, Christians are not mere reflectors of God's glory; but there is a light beaming from within them which *makes them luminous,* for they are made to resemble Christ in their character; they are created anew in the image of Christ; they are begotten of him, and are said to "put on the Lord Jesus Christ." All true Christians do thus resemble, at least in some degree, the Saviour.

But Christ is the grandest manifestation of the Godhead ever made to creatures. He was "the brightness of the Father's glory, and the express image of his person." No other display of the Godhead can be compared with that of the Word made flesh. And surely it must follow that creatures who resemble him must reflect, in the highest degree, the glory of God. Angels may be perfect in holiness, but their character does not present the same moral aspect as that of Christians who have been saved and sanctified. Both will be holy; but in the character of a perfectly sanctified Christian there will appear many things which an angel never can exhibit. It will resemble that of Christ more than that of Gabriel, and in so doing will manifest the glory of God as it shone in the face of Jesus Christ.

To what an honorable and exalted position does the Bible advance the Christian! Set in the firmament of intelligent beings, he shines with a peculiar light, like a star whose beams emit a peculiar halo, and whose

twinkling disc wears a brighter effulgence than its fellows. "The heavens declare the glory of God, and the firmament showeth his handiwork." Angels reflect that glory in a higher degree; but sinners raised from guilt and ruin, and made sons of God, furnish the grandest exhibition of the divine perfections ever made. Such is the relation Christians sustain to God and to other intelligences—they are reflectors of God's glory.

But when I read my text I learn that they are not mere passive reflectors. They are to give light not merely as polished mirrors hung in the sunbeams; they are to shine from within, as well as on the surface. There must be a settled aim and purpose to scatter light about them. "Let your light so shine," says Christ. The word "*so*" here implies that you have a deep responsibility as to the kind of light you give, and the effect produced by it. It is a light which must be made to shine through your good works, your holy lives. And those works must be prosecuted in such a way that men shall be led by them to "glorify your Father which is in heaven." Here is the great law of Christian activity: that all you do shall be done in a way which shall tell for the glory of God. Christian friend, here is the governing principle of your life. It requires you to act with reference to the good of others. It bids you keep ever in view the influence of your conduct upon those around you. 'Tis a high, a noble principle—the glory of God. 'Tis an unselfish principle, which will enable you to display to the world all the graces of a holy life without pride or ostentation, and so to walk

that men will give God the glory of any good they find in you.

Ah, we fear it is a principle too often wanting, even with those who profess to be God's people. Many have no objection to let their light shine while they can be appreciated; many are willing that others shall see their good works, and glorify themselves for them; many will devote their time and labor to the cause of Christ so long as they can have the preëminence, and impress others with the idea of their own importance. Their light will shine, but shine only to let the world see their own perfections, and pay homage to their sanctity.

But far different from this is the spirit of a Christian's service. It is not self, but God who must have all the glory. Let it *so* shine, says Christ, that it shall lead all who see it to render God the glory. Let ungodly men learn from your holy lives the reality and excellency of that salvation which you have tasted. Let the light of your example shine so that they too shall be led to seek the same divine illumination. Let all your works point them to that Redeemer who has called you out of darkness, and prompt them to seek him as their own. Thus will they glorify your Father which is in heaven.

Such is the spirit of the Saviour's words before us, and the practical inquiry for us all is, How do our lives correspond with this spirit?

First of all, have we really any light to shed around us? A mere profession is worthless as an empty lamp.

Have our hearts been illuminated by divine grace? Has the darkness of guilt and ignorance and error been scattered there; and have we tasted the sweets of pardon, peace, and sanctification?

Depend upon it, we can give no light to others without first having our own hearts illuminated by the Holy Spirit. A mere profession of religion, unaccompanied by the active virtues of piety, will give no light. Let us then look closely within, and ask, Have we any light of grace ourselves? And in connection with this, and following it, will come the inquiry, What good are we doing to the world by it? Oh, my brethren, the Saviour bids us look around us upon our fellow-men and ask, What has all our religion amounted to? What have we accomplished for God's glory? How much light have we scattered? Whom have we enlightened and saved through our Christian influence? What souls have we led to repentance and belief in Jesus Christ? Has our light shone to any purpose? Have we been the instruments of instructing and saving others? Inquiries like these must come up, for God's people are the light of the world, and their mission is to reflect his glory as no seraph even can do it. It therefore follows that the question of your influence upon the world around has vitally to do with the question whether you are a child of God at all; for if there is no light radiating from your life, there is none in you. If your light does not shine, it is because you have none; wherever it exists in the soul it must shine out.

Every Christian has a positive influence for good. All do not shine with equal power and brilliancy, but they shine. Some scatter their rays far and wide, and become the moral lights of their generation, and some only glimmer like a feeble taper; but even the taper gives light to some, and so every Christian must shed rays of light upon some soul.

Christian friends, where are those rays falling from your lives and conversation? Whose way do they enlighten? Do your children see them? And have you, by the lustre of your Christian example, led a single soul to Christ? Oh look well to the influence you are exerting. Beware lest your profession be in vain; for "if the light that is in you be darkness, how great is that darkness!"

VII.

The Raven and the Dove.

AND IT CAME TO PASS AT THE END OF FORTY DAYS, THAT NOAH OPENED THE WINDOW OF THE ARK WHICH HE HAD MADE: AND HE SENT FORTH A RAVEN, WHICH WENT FORTH TO AND FRO, UNTIL THE WATERS WERE DRIED UP FROM OFF THE EARTH. ALSO HE SENT FORTH A DOVE FROM HIM, TO SEE IF THE WATERS WERE ABATED FROM OFF THE FACE OF THE GROUND. BUT THE DOVE FOUND NO REST FOR THE SOLE OF HER FOOT, AND SHE RETURNED UNTO HIM INTO THE ARK; FOR THE WATERS WERE ON THE FACE OF THE WHOLE EARTH. Genesis 8:6-9.

The narrative which contains these words introduces us to one of the darkest and most desolate periods in the history of our world. Rapid and appalling had been the progress of human degeneracy. Religion and virtue had well-nigh become extinct, and all flesh had corrupted its way on the earth. The good men of the antediluvian age were dead, while but one of the hoary patriarchs was left to bear witness for Jehovah before a God-despising generation, and to perpetuate the succession of the faithful in the world. It was time for God to work, for men had made void his law. The vast population of this globe was swept away by a deluge of waters—that most awful visitation of divine vengeance, the evidences of which are to this day found, and the traditions of which are preserved among the primitive nations of every continent.

Righteous Noah and his household were alone preserved by special divine interposition. Forewarned of God, he prepared an ark for the saving of himself and his family, which in due time was freighted with the remnant of the human race and pairs of the various tribes of the irrational creation, and floated upon the wide waste of waters, beneath which lay buried all the monuments of an apostate and heaven-daring generation.

Forty long days were numbered after the flood began to abate, and still the huge ark floated on the boundless deep, and the patriarch's heart grew anxious about the future. With a trembling hand he opened the window of the ark, and sent forth the raven to seek for some tidings of a buried world; but the bird came not back. Though the waters were dark and the desolation unbroken, still she returned not to the friendly shelter which had so long protected her, but chose to allay the cravings of hunger, and live amid the wrecks and ruins which drifted to and fro upon the broad abyss. Days again pass slowly away. Another messenger is dispatched to seek for tidings. The dove leaves the window of the ark, and spreads her pinions and soars away over the wild expanse; but the unpropitious skies are overhead, the green fields and shady woodlands are gone; no nourishment is found amid the shattered fragments, and no objects of delight are seen across the dreary wastes. The raven may perch upon the drifting offal, and screech out its hoarse notes amid the awful solitudes; but the timorous dove, finding no rest for

the sole of her foot, hastens her flight back to the patriarch, and nestles securely in the friendly ark.

There are materials for profitable reflection in this simple story. Let us condescend to learn lessons of true wisdom from the raven and the dove.

1. In the solitary ark floating securely on the flood you may discover no unfit emblem of that *only spiritual refuge* which God has provided for our ruined race in the person and work of his Son Jesus Christ. The fearful apostasy of our first parent drove our race out upon an ocean of gloom and of peril. The special presence and favor of the Almighty was withdrawn, though his providential care over us as his creatures remained. But purposes of mercy were yet cherished in the divine mind, and the plan of salvation was revealed through Jesus Christ.

Here alone, in Christ, God manifests to us his gracious presence. Nowhere else in all the departments of his works does he admit us to his fellowship, or speak to us of his mercy. Take away from the world the special manifestation of God in Christ, and there is no way left for man to hold any communion with his Maker, no pledge of mercy or grace to him, no hope of security and happiness in the favor of his Sovereign. Man is left to drift on the dark billows of sin without a ray of deliverance, and without a single speck floating upon the wide expanse to tell him that he is not utterly abandoned to destruction.

But never has our world presented such an aspect of hopeless desolation. Even in the awful catastrophe of the deluge, when continents and isles with their teeming population were buried deep in the abyss of waters, and the sunbeams glistened only upon the boundless sea—then, when this rolling orb, which on the day of its creation looked fair and beauteous among the morning stars, had been transformed into a wandering beacon of almighty wrath—there was left one memento of lingering mercy, one solitary testimonial that Jehovah's presence and favor were not clean gone for ever; for the ark floated upon the face of the waters. Terrible as was the spectacle which the deluged globe presented of God's vengeance, still the storm-proof ark which sheltered the patriarch proclaimed the precious truth that there was one spot left where God appeared in mercy, one place of refuge and security for those who would embrace it, one point where hope gleamed over the future, and where God delighted to be gracious.

The ark was the symbol of that more glorious Ark of safety provided for lost men in the salvation of Jesus Christ. Out of Christ the world is dark and stormy, and God is a consuming fire. On the tempestuous ocean of guilt we are tossed to and fro, and no bright isles of innocence lift their heads along the horizon and invite us to their secure retreats. The salvation scheme of Jesus Christ is the only refuge. Here alone God is seen hovering over the waters, and speaking of reconciliation and fellowship. Nowhere else has he offered to us a shelter; but to this God-provided Ark we are bidden to flee for refuge, which is amply

furnished against every emergency, and which will safely bear us up through the floods of temptation and the billows of death, and finally bring us to the haven of rest beyond the grave.

To its sacred enclosure we are invited, as the last spot where the soul can find its reconciled God. Outside the elements are raging, the night of guilt is brooding, the thunders of Sinai are muttering, and the dun-colored sky is lurid with the flashes of impending wrath; within is the presence of God, the assurance of peace, and the hope of heaven. Over the wastes of a fallen and sin-ruined world appears the salvation of Jesus Christ like the ark of the patriarch riding out the storms of the deluge. Here God is dwelling with men. Here is rest to the storm-driven soul. Here its guilt and alienation are put away from it, and it no longer lives without God and without hope. We have then discovered, in the ark which God directed Noah to build for the saving of himself and his family, a type of Christ and his salvation.

Let me now ask you to advance a step, and contemplate in the raven and the dove a representation of *two opposite descriptions of human character*. The one, that which finds no enjoyment in the presence and favor of Christ, and sees and feels no necessity for the provisions of salvation which are made in him; the other, that which is ever turning from the supports of this world and its delusive promises to seek its refuge and its resting-place in the presence of Christ and the favor of God, which flies to the hope set before it in the gospel, and nestles

securely in the bosom of the Saviour. These two characters are the ungodly and the Christian—the children of this world and the children of God—differing in their tastes and habits and conduct from each other as the raven differs from the dove.

The ark where God and the patriarch dwelt together was no welcome retreat for the raven. Though it had saved the wild bird from inevitable destruction, and for many a weary day had carried it safely above the angry flood, still in the society which it afforded or the associations which it furnished there was naught that was congenial to its untamed nature; but preferring to roam unprotected, even amid solitude and gloom, it instinctively seized upon the first opportunity to escape what was indeed its friendly asylum, but which appeared to it only a prison-house. On the threshold of the open window the raven flapped its wings and soared away. Farewell to the ark, screamed the wild bird in the air, while the good old patriarch stood for a moment to watch its flight.

Though the scene without was one of unbounded desolation, where the storm clouds revelled and the fierce winds blew and dashed the dark-crested waves madly against the sky; though the fields where it once fed, and the tall trees where it was wont to build its nest were buried many a fathom deep beneath the floods, and all that was once fair and beautiful on earth was gone, still the bird of storm turned not homeward to the quiet ark; still in vain the patriarch opened again and again the window, and leaned upon the casement long and anxiously, to look out for

the absent messenger. The bird would not come back. The sun goes down in clouds, and night settles slowly on the deep, but no return. The cravings of hunger are felt, but the carnivorous rover despises the well-stored granaries of the ark, and makes its evening meal out of the carcasses that drift upon the waters. Perched upon some floating ruin, it croaks out its hoarse requiem over the sepulchres of the unnumbered dead, and sleeps without a dream of the far-off ark.

Look yonder at that RAVEN, and behold an emblem of lost and straying man without God in the world. No truth is more universally certain, than that man's real happiness and welfare is to be sought only in the smile and favor of his God. The more the human soul is brought into unison with its Maker—the nearer it advances to Deity—the more immediately it feels the presence of God and draws its supplies from him, the more sure is its present peace and its future bliss. It was once happy in this condition. Adam and God were friends. The primary effect of sin has ever been to separate man from God. The example of our first parents in hiding themselves among the trees of the garden, from the voice of the Lord, is an example which has been imitated by all the generations of their descendants. But the intervening distance between us and God has been surmounted by the Mediator. The fearful chasm has been spanned, and God now draws nigh unto us in the gospel of his Son, and invites us to draw nigh to him. Here, in the plan of salvation, he bids us accept of his grace. Here is the ark of safety, where no thunderbolts of his wrath will strike us, but

where we may rest securely from the storms of the present life, and the retributions of the coming one. Here we are told to flee for refuge and hope. And once sheltered in this ark of salvation, we may have God our friend, and Jesus our Saviour. An open door is set before us, and the invitation given, "Come thou and all thy house into the ark."

But carnal man prefers to roam. Tossed upon the troubled waters of life, where all is danger and uncertainty, he still persists in neglecting the great salvation, and like the raven, flies to and fro in search of happiness and safety. Life, to men without God, is but a chartless ocean, over which they course their way amid floating wrecks and ruins, vainly bent on satisfying the soul. High on the waters rides the ark of mercy, and the voice of God is heard inviting them to enter. But though the skies of life are so changing, and its waters so dark and troubled, that they ofttimes feel the need of better resources, still they look not to the gospel, but toil and fly from one to another quarter, crying, Who will show us any good? They want nothing to do with God. They care not for his favor. They prefer to live as far away as possible, and seek all their support amid the resources of the world.

Look at the sceptic, who, giving himself over to the dominion of infidelity, would blot out eternity from the future, and would repudiate the very being and the presence of the Almighty. As he travels through life away from God, and with no hope for the future; as immortality is to him a blank, and the world naught but chaos over which destiny and chance

preside, and death is an eternal night, to what shall we liken him, but to the raven, far off from home, flapping its wings in the empty air where every thing that once breathed was dead, and where all was silence, desolation, and gloom.

Watch the men that toil for the riches of this world, who day by day ply their exhausting labors, and nightly dream of treasure heaps and gold, while God is put far from their every thought, and the gospel is neglected, and eternity thrust away from them, and the soul is left to glean its only comforts amid the perishable and fading possessions of earth, like the wandering bird scouring the unbroken main, and seeking its abiding place among the floating wrecks of ruined palaces of bygone splendor.

Or what shall we say of those who banish from their minds the thoughts of God, and live only in the round of sensual indulgences, prostituting their every faculty to the service of the basest appetites, and giving an unbridled rein to sensual propensities? Where shall we find their prototype, but in the bird of prey that loved to breathe the putrid air, and gorge its appetite upon the carcasses which the waves washed up.

In short, differ as men may in their individual tastes and habits, there is this one prominent characteristic belonging to them all—an utter estrangement from God and Christ: an estrangement so inveterate, that all the trials and afflictions and disappointments of life are insufficient to bring them to seek security in

him. Like the wandering raven, they fly from one to another refuge; "but none saith, Where is God my Maker, that giveth songs in the night?"

We turn now to consider the opposite description of character which is symbolized by the dove, which found no rest for the sole of her foot, and hastened back to the ark.

It is the Christian who has been brought near to God, and lives in the enjoyment of his presence. Once, like the raven, he loved to wander, and with the ungodly around him, he careered his way without God, and chased to and fro the vanities of this world. But by the regenerating grace of God, he is changed into a man of another spirit. The alienation and distance between him and God have been overcome, and he now finds his happiness in the felt presence and communion of that God from whom he has so long turned away.

'Tis the peculiar characteristic of the Christian, that he seeks, in the favor and presence of God, those delights which the ungodly strive for in vain among the objects of the world. He differs from them in his tastes and pursuits. He seeks in one direction, they in another. The current of his desires is so changed, that he feels estranged where they are most at home. What they most value he cares but little for. The company they delight in, he has no real sympathy with. He sits not in the seat of the scorners, but his delight is in the law of the Lord, and in his law doth he meditate day and night.

He may engage in the pursuits of secular life; he may be seen in the places of business and toil and enterprise, and bear a share in the rough struggle of the outdoor world; yet his chief pleasure is not found amid the cares of business and the schemes of profit, but in the fellowship of God and in the duties of devotion. Here his soul abides in peace. The service of Christ is congenial to his spiritual nature. His better thoughts ever dwell upon the unseen and eternal. Business and care may crowd upon him through the day; but he turns his footsteps homeward when the sun goes down, and like the dove returning to the ark, he seeks communion with God in the meditations of the closet. It is to him a welcome exchange to leave the bustling companionship of the world for the society of the Saviour. While the ungodly revel amid their tumultuous gayeties, he finds in the retirement of his devotions those joys that a stranger intermeddleth not with, and feels that as the hart panteth after the water brook, so panteth his soul after God. While temptations thicken around him, and strange voices are calling to him and bidding him wander further and further away, he still finds his only security in the presence of the Saviour, and flies to him like the dove to the arms of the patriarch.

God is his refuge too in the season of affliction and trial. Sometimes the world grows doubly dark, and crosses and disappointments overwhelm his soul; but the dove knows where to turn when the storm rages, and he flies for support and consolation to the presence of the Redeemer. In the time of trouble God will hide him in his pavilion, in the secret of his

tabernacle will he hide him, till these calamities be overpast. It is the prevailing desire of the Christian to seek after God. Afflictions, crosses, and disappointments all drive him there. Like the dove wandering with weary wing over the dark abyss, he finds no rest for the sole of his foot till he betakes himself to the hiding-place of Jesus, and reflects how, ere long, the rough billows of life will be passed, and he shall be safely moored in the calm haven of eternity.

Pause here a moment, and reflect upon the radical difference between a true Christian and a worldling. The one is brought nigh unto God; the other is without God in the world. In the prevailing bent and purpose of their lives they are opposites. Their dispositions lead them in contrary directions. The providential dealings of God with them produce widely different results. The same storms of affliction which drive the Christian, like the dove, homeward to his refuge, ofttimes tempt the ungodly to fly, like the raven, further and further from the Ark of safety. "The wicked will not seek after God."

These are the two great classes of human character which the Bible everywhere distinguishes. To one or the other class we all belong. We may multiply our distinctions between men as we please, and assign to one and another his relative position in the scale of human excellence; but at the last there will remain but one broad line of separation between those who walk with God, and those who know him not. Tried by this test, where shall we be found? When the last storm of

death shall gather, and the world be swept away from us, shall we be borne in the Ark of safety to the Ararat mountains of the heavenly land, and rest beneath the effulgent bow of the Redeemer's glory; or shall we be driven out upon the shoreless waters of an eternity where the storms never cease their fury, and where the blackness of darkness for ever broods?

This momentous question of our future state is being settled by our present character. Are you living now in the fellowship and favor of God? We are told of the patriarch who rode out the deluge, that through the long previous years he "walked with God." Is such the temper of your soul? Are you at home with Christ? Is God the portion of your spirit, and do you love the consciousness of his presence, and do you fly to him for aid? Can you live here within his covenant, and conform to his requirements, and lay hold upon his promises? Can you count all things but loss for him, and give up the world with its pleasures and its charms for the society and the service of the Lord Jesus? Or do you prefer to live a stranger to Christ, and a worldling in your desires and habits, without a shelter, though eternity must be to you a state of exile from all the holy and happy family of God?

VIII.

The Rainbow.

I DO SET MY BOW IN THE CLOUD, AND IT SHALL BE FOR A TOKEN OF A COVENANT BETWEEN ME AND THE EARTH. AND IT SHALL COME TO PASS, WHEN I BRING A CLOUD OVER THE EARTH, THAT THE BOW SHALL BE SEEN IN THE CLOUD. Gen. 9:13, 14.

The old world is gone. Its teeming population has been swept away by the besom of Jehovah's wrath. The earth has been purified by the terrible baptism of water, and refitted to be the dwelling-place of new generations. Noah and his family are its sole inheritors. The human race are starting anew as it were, in a new world.

The Almighty signalized this grand era in the world's history by a special manifestation of himself to Noah, the chief representative of the future generations. He entered into covenant with him; he gave him a new grant of eminent domain, formally installed him as the rightful possessor of the earth, and bade him repeople it and rule it.

Most cheering must have been such tokens of favor and regard from the Almighty to that lone, solitary family as they looked over an empty, desolate world.

Although they were saved, yet an air of deep sadness and melancholy must have rested upon every thing

around them. The recollection of those awful scenes through which they had passed must have haunted their thoughts, and troubled their slumbers with frightful dreams. What if the sun shone again in beauty? What though their children should multiply, and they should again build cities, and repeople its desolate territories? Would not the storm clouds gather again, and the race be swept to destruction by similar successive judgments? Ah, would they not look up with terror every time the heavens grew dark, and fear lest the world should be drowned whenever the rain descended?

To allay all such apprehensions, while he commissioned them to repossess the earth, Jehovah assured the patriarch that the deluge would never be repeated. He kindly condescended to enter into covenant with Noah, that he and his posterity need have no fears of a second deluge; and promised that he would never do what he had done, and drown the world. The text declares to us what was the outward sign or token of this covenant: "I do set my bow in the cloud, and it shall be for a token of a covenant between me and the earth. And it shall come to pass, when I bring a cloud over the earth, that the bow shall be seen in the cloud."

The idea that the rainbow was something more than a mere natural phenomenon, that it was a pledge or token of something which God had promised to men, is preserved among the traditions of many heathen nations. Homer distinctly speaks of it in a remarkable passage in the Iliad, where he describes the glittering

armor of Agamemnon as reflecting various lights, like colored rainbows—

"Jove's wondrous bow,
Placed, as a sign to man, amid the skies."

Before considering the spiritual significance of this symbol, the inquiry naturally arises, Was the rainbow a new phenomenon in the natural world, seen for the first time after the deluge; or had it been a familiar sight to the antediluvians ever since the creation, and only selected by God and pointed out to Noah as a memorial of His promise made to him?

The man of science may presume to decide this question very easily by showing that the rainbow is no supernatural phenomenon, but is explained on the simplest principles of natural philosophy; that it is produced by the refraction of the sun's rays through drops of water falling from the clouds, and is always seen when the sun and the clouds come into a certain relative position to the beholder; and therefore, that through the centuries previous to the deluge, mankind must many a time have witnessed the same beautiful arch spanning the heavens, and wondered at its variegated splendors.

But there are other considerations which have inclined learned and profound scholars to the opinion that the rainbow, for the first time mentioned in the text, was indeed new to Noah and his family, and that the generations of men before the flood never gazed upon such a sight.

We confess a strong bias to this latter view. It lends peculiar interest and significancy to this token. It is the sign of the promise that God will not again drown the world. Clouds may gather, storms rage, torrents roar, but their fury shall be stayed; and on the spent and receding clouds shall be hung the sun-lit bow, and from every tint and hue of its gorgeous drapery shall come whisperings of assurance to mortals who gaze upon it, that mercy triumphs over judgment.

"I will set my bow in the cloud," says Jehovah. There, in the midst of the very elements which have caused alarm; there, where the lightnings flashed and the thunders pealed, and wrath and darkness gloamed overhead, there will I write my covenant in lines of beauty, and you and your posterity shall read it and rejoice.

But we need not stop with interpreting this symbol as a pledge against a mere physical overthrow of the world by water.

We seek for a deeper spiritual significance in it. Although in its primary application it was a sign of God's covenant with Noah, it leads our minds forward to a more perfect covenant, a covenant of grace, in which are contained the promises of God which shield his people from all spiritual evils which threaten them.

The import of the rainbow in its spiritual signification is worthy of special notice. We do not explain it so generally as some who regard it as a symbol of God's willingness to receive men into favor again, or that it

only indicates the Almighty's faithfulness in fulfilling his promises. We interpret it more specially as a symbol of divine protection to God's people from imminent and threatening dangers — that protection pledged in the covenant of grace in Christ Jesus to those who have fled for refuge to him. Such seems to be the idea conveyed by it in the vision of Ezekiel, where he speaks of what he saw over the throne above the heavens "as the appearance of the bow that is in the cloud in the day of rain." A similar sight was enjoyed by John in Patmos, where in vision he beheld the throne in heaven: "And there was a rainbow round about the throne, in sight like unto an emerald."

These references to the rainbow justify us in interpreting it as a symbol of grace returning after judgments; a pledge of God's promise to stay the course of vengeance, to limit threatening evils that they shall not destroy, to arrest impending dangers, and succor his people when they are most exposed to destruction.

The bow in the cloud then is not a mere sign of God's fidelity to his promises in general, but a particular token of his grace nigh at hand in emergencies, a sign for the hour of trouble and distress and alarm, a token of grace — not when the sky is clear, but when the heavens frown, when fear comes to the soul and it looks anxiously round for help. As a physical phenomenon it had this significancy. God set it in the cloud. It was brought forth only in the darkened heavens. It was nursed and cradled in the storm.

When therefore, at summer's sunset, I gaze upon the beautiful iris arching the eastern horizon and resting on its dark background of clouds, my thoughts go out beyond the covenant of Noah to a richer covenant of grace, and I read in its gorgeous colorings a pledge of those provisions against spiritual dangers made in the mediatorial work of Jesus Christ. While the physical eye is delighted with the beauteous spectacle in the lower heavens, faith soars upward and sees around the throne of the Almighty's glory a brighter bow set there through the mediation of the incarnate Son. It is the pledge and token of grace to sinners. It is the sign of the covenant of redemption.

When, upon the apostasy of man, the heavens gathered blackness and the clouds of divine wrath swept overhead, portending a deluge of divine justice; when the guilt of our transgressions left us with no covering from the eternal storm, the eternal God placed himself between us and hell, and by his own sacrifice upon the cross drew upon himself those magazines of vengeance. The divine law was satisfied in his atonement; the clouds broke and scattered around the Almighty's throne. Light streamed athwart the gloom, and the Sun of righteousness, with healing in his beams, threw out its rays upon the retiring storm, and arched the clouds of justice with the brilliant bow of peace and reconciliation. Every rainbow painted in the natural heavens points us to what Christ has done in the spiritual world. The physical eyeball sees the one, faith gazes upon the other. Both are associated with the idea of danger, both bespeak security and deliverance.

You perceive then the spiritual lesson conveyed to us by the rainbow in the clouds. It tells of God's covenant of grace with his people, and the promises under that covenant of safety in the midst of fears.

How adapted is this lesson to the condition of believers in their present state. Oh, what could faith do without the bow in this stormy, troubled world? How many are the clouds which darken the believer's way! But God has set his bow in every one of them — his pledge of deliverance and support.

Sometimes the dark cloud of his own transgressions settles terribly upon the Christian's soul. The convictions of his heinous guilt almost drive him to despair. He asks himself, How can mercy reach so vile a sinner? how can such iniquity as mine be pardoned? Vainly does he look within himself for any thing to hope for. Ashamed and speechless, he has no satisfaction for the law's demands. That law condemns him, conscience condemns him; but faith discovers deliverance in the atonement of the Lord Jesus. The covenant breaks upon his soul — his Saviour has died for him. His guilt is fully atoned for; and there is the bow of the covenant promises lighting up the cloud. "I will set my bow in the cloud," says God, and when Sinai thunders in the soul I will arch its summit with the iris from the cross.

Again, how do the clouds of temptation sometimes thicken over the Christian's way — temptations from within and without. And what discouragements press upon him from the rising corruptions of his heart and

the onsets of the world. How often does he groan under his own weakness, and ask, Can such a one ever get through to heaven? But lo, in the covenant there are promises exactly meet for his condition, that he shall be held up to the end; and faith discovers bows in all these clouds, which whisper to him of final triumph.

In those clouds of temporal disappointment which frequently overshadow him, marked by the failure of business enterprises, want of success in one and another undertaking, and which doom him to the lot of toil and poverty—in those clouds which stamp the seal of failure upon his mere earthly life, God sets his bow to comfort all his people. It is the promised inheritance of heaven; the recompense of the reward—the treasures which wax not old. Here is the Christian's comfort under the reverses of earthly fortune, and the clouds soften and break while faith gazes upon the bow above them.

When life's blackest clouds gather, in the forms of bereavement and death, there are promises enough in the covenant to gild them all. "It shall come to pass when I bring a cloud over the earth, that the bow shall be seen in the cloud." This is God's covenant promise to his people. And would you know how faithfully he keeps it, contemplate the experience of God's true people in trials, when the world was dim with shadows. Call to mind your own experience, faithful one. Did you not find treasured in the promises of grace such comforts as you never knew before—a power in prayer, a drawing near to Christ, a witness

of the Spirit—all producing a peace and resignation which kept you from despair?

In all this discipline of trials, God reveals his resources to his people; and in the abundant consolations provided for them, and which Christian faith appropriates, in the strength given in trials, in the clear shining of the promises athwart the clouds of adversity, they discover the beautiful significancy and the actual fulfilment of Jehovah's pledge and token to the patriarch, that he would set his bow in the cloud, and when he should bring a cloud over the earth, the bow should be seen in the cloud.

Have you, my friend, a vital interest in that covenant of grace, which arches life's stormiest days with the bow of peace, and contains the pledge of salvation in the future life? These blessings are *covenant* blessings. They come not to us naturally, as a matter of course. They are secured only by a special stipulation—an arrangement which God has made through Jesus Christ, as a Saviour and a Mediator. They belong to us only by faith in Him who purchased them. Have you accepted the conditions of grace: repented, sought forgiveness, given your heart to God, solemnly embraced the covenant? Only by so doing can you enjoy the benefits. Only by resting under the everlasting covenant can you look up and see the bow.

Ah, you may stubbornly persist in impenitence, but you will find dark days ere long. Ere life be through, the skies will grow dark and troubled. Clouds of

divine wrath will hang overhead. Clouds black as those which gloomed on Sinai's summit, will marshal their fearful elements, and fill you with alarm. Persist in impenitence, and you will hear naught from them but thunder-voices of a violated law, and see naught but vivid flashes of retributive justice. No promises of deliverance fringe their edges with a thread of silver light; no sunshine of hope breaks between them to scatter them; no bright bow of safety spans the firmament, and publishes Jehovah's pledge of reconciliation. Outside the covenant they are clouds of wrath, portending an eternal deluge of fiery indignation which shall devour the adversaries of God. Fly then for refuge; fly to the shelter of the covenant. Come to Christ Jesus for salvation. Come before the storm breaks in fury. Come where you can stand and see the bow when life's tempests sweep; when the heavens are dark; when the night of death settles.

IX.

The Smoking Furnace and Burning Lamp.

AND IT CAME TO PASS, THAT WHEN THE SUN WENT DOWN, AND IT WAS DARK, BEHOLD A SMOKING FURNACE, AND A BURNING LAMP THAT PASSED BETWEEN THOSE PIECES. Gen. 15:17.

The scene here described between Jehovah and the patriarch is one of awful and mysterious interest. Long ago, when he came out of Ur of the Chaldees, God promised blessings to Abram and his posterity. But as yet there were no signs of the fulfilment. Many years had since rolled by, years of fluctuations and trials. The stirring events of the war of the four kings and the deliverance of Lot were brought to a close; and Abram had once more retired to a quiet pastoral life, rich, honored, powerful among the surrounding tribes.

But though he had grown great, there was one corroding care which preyed upon his heart. Ah, what condition of human life is there, which has not its secret sorrow? What house so bright as never to have a shadow across its hearth? Abram was treading along the vale of years, childless and a stranger. Eliezer of Damascus seemed likely to inherit his vast possessions.

At this period, when Abram's anxiety deepened, and hope began to grow impatient, God appeared again to

him in vision, and renewed his covenant promises. And in answer to the patriarch's request for some outward sign or ratification, the Most High directed him to slay a heifer, a she-goat, and a ram, and divide the parts, and set them the one over against the other, that one might pass between the parts.

In ancient times the ratification of covenants was attended by the most solemn rites, in which the contracting parties participated. In the 34th chapter of Jeremiah there is an explicit reference to a ceremony like the one here described: "And I will give the men that have transgressed my covenant, which have not performed the words of the covenant which they made before me, when they cut the calf in twain and passed between the parts thereof—the princes of Judah, and the princes of Jerusalem, the eunuchs, and the priests, and all the people of the land, which passed between the parts of the calf—I will even give them into the hand of their enemies." In these solemnities the contracting party or parties passed between the parts of the slain victim, in token of their full assent to the stipulations made, imprecating upon themselves a most bitter curse if they should violate them. The ceremony was of the nature of a most solemn oath.

Nor was it confined to the Israelitish nation alone, but similar rites were observed among other people. In the third Book of the Iliad, Homer describes the solemn ratification of the covenant between the Greeks and the Trojans, according to the terms of which Menelaus and Paris were to determine the

great quarrel between them in single combat. Victims were slain, their heads distributed among the chiefs of the hostile parties, their palpitating limbs placed opposite to each other on the ground, while the officiating priest uttered a prayer to Jupiter, accompanied by a most awful imprecation upon any one who should break the solemn oath. Livy also, the Roman historian, records a like solemnity on the occasion when the Roman and Alban nation agreed to settle their contest by the combat of the three Horatii and the three Curiatii. Then too the Roman priest slew the victim, and called Jupiter to witness their vows, and strike the violator as he struck the victim.

In this fifteenth chapter of Genesis, the sacred writer describes a sacred institution, which Homer, a thousand years later, found among the Greeks; and the Roman historian, still later, records as in use among his countrymen. The intent, or meaning of the solemnity, was evident. Abram well understood it; for without any particular instruction recorded, he prepared the sacrifice.

It must have been a day of overwhelming interest to the patriarch. Early in the morning God directed him to make his preparations. He obeyed with promptness, and slew the animals, and arranged their parts upon the ground. Having passed between them himself, thus acknowledging his obligations in the covenant, he sat down alone to wait for Jehovah to signify his presence. What strange, unearthly thoughts revolved in his anxious mind! What a

condition for a creature to be in—a lonely man watching for God to come!

The day wore by; the sun was far down the west; the shadows were deepening on the earth: the weary patriarch dropped his head upon his breast, and slept. A horror of great darkness fell upon him; and then came a vision and a voice, which revealed to him the future. When this had passed, night had set in; and in the darkness the weary watcher waited, near the limbs of his slain victims, for Jehovah to reveal his presence and seal his promises, till at length, through the thickening gloom and spectral silence, the Shechinah is discovered, moving in awful majesty near the sacrifice. A smoking furnace and a burning lamp passed between those pieces.

Abram understood it all: God's visible presence was before him; Jehovah had ratified his covenant; the deed was done. The patriarch was satisfied. He had not been imposed upon by his fancy; he had not been deceived by some *ignis fatuus*. It was Jehovah's presence he had looked upon; it was Jehovah's own doings, making his covenant sure to him.

Yet all he saw was a smoking furnace and a burning lamp pass between the pieces. He heard no voice; he saw no living personal form: but that appearance before him was Jehovah's sign. He doubted not a moment; he asked for nothing more. It is evident that the manner in which God signified his presence on this occasion had a peculiar significance in it, that there was a peculiar fitness in the form which he

assumed—*a smoking furnace and a burning lamp*—rather than some other visible form.

We believe that these signs indicated not only that Jehovah was there, but who that Jehovah was. They exhibit God as *hiding, and yet revealing* himself. The smoking furnace, dimly visible, and followed by the burning lamp, presents the side which the Almighty turns towards us, marked by *obscurity, and light*. The Most High is known, and yet unknown; revealed to us, and yet concealed.

And we believe that a correct view of God, as exhibited to us in his word and providence, will correspond with the view which the patriarch had of him in the loneliness and darkness of that night, when He sealed His covenant with him.

We hold that in the goings forth of his providential government for thousands of years, and in the utterance of his word, there are the same traces of light and obscurity, of concealment and illumination, which were symbolized to Abram; and the same God who passed between the pieces of his sacrifice under the form of a smoking furnace and a burning lamp, is still passing before us all in a like manner.

Such is the Almighty whenever he turns himself towards us. And while I gaze with the patriarch upon the awful solemnities of that hour, that smoking furnace and burning lamp seem to move, not only across that spot, but over the ages and the world, and indicate the presence and the doings of God in all the conduct of his government.

Turn first to the *written revelation* which he has made to us through prophet and evangelist. In the very first promise made to man after the fall, so dim yet cheering, did he not pass before Adam much as he did before the patriarch? In that promise of the seed of the woman bruising the serpent's head, so vague, so indefinite and obscure, there seems at first only the smoking furnace; but while we steadily look at it, it brightens into a burning lamp, which beckons faith to look down the future and hope for deliverance from the curse.

In all that God has revealed of himself and his purposes in his word, he passes before us in mystery as well as light. He lifts the veil but a little way; he allows us to see but a part of his plans and doings.

The prophetic parts of the Old Testament Scriptures illustrate this blending of obscurity and light. The predictions of a coming Messiah were clear, and yet mysterious; so that the Jews failed utterly to interpret them aright, or to recognize Him when He appeared as "He of whom Moses and the prophets did write." Those predictions now appear plain to us, for we study them in the clear light of their fulfilment.

In like manner, other prophecies of great events which have already been accomplished — as the Babylonish captivity, the overthrow of ancient cities and kingdoms, and the destruction of Jerusalem — now seem to us most graphic and distinct, because history and facts have thrown their light upon them. But of those prophecies which yet await their

fulfilment, how true is it that a veil of obscurity still rests upon them. How various and conflicting have been the theories of those who have anxiously studied them. The restoration of the Jews, the destruction of antichrist, the second coming of Christ, the millennium reign—these and the like subjects have taxed the ingenuity of the learned for ages. Yet all have failed to find out the Almighty's specific programme, or to tell beforehand what shall be the exact fulfilment. The God of prophecy passes before us as a smoking furnace, and a burning lamp.

The strictly doctrinal portions of God's word exhibit him to us in this twofold attitude of obscurity and of light. Plainly enough has he revealed to us our duty. Clear and authoritative is his voice, speaking to us in the Decalogue. The burning lamp shines clear and steady through all the preceptive deliverances of the Scriptures; but ah, the great questions and paradoxes which have perplexed the human soul in all ages, the unsolved problems of natural religion over which thought has wearied and despaired, are left unanswered. How sin could be allowed to enter a moral system; the harmony of the divine foreknowledge with human freedom; the election of grace; man's moral helplessness and responsibility—these and such like subjects remain unexplained. Revelation does not attempt to lift the mysterious cloud which still hangs over them. Jehovah condescends to no explanation of his doings; nor by a single word does he seek to vindicate the infinite wisdom of his administration. Clouds and darkness are round about him. With none of us does he take

counsel. The great truths of revelation reach beyond our grasp. We see but in part, and we know but in part. The gospel brings us near to God; but even there he covereth the face of his throne. The intermingling of obscurity and light which was symbolized by the smoking furnace and the burning lamp, characterizes the entire field of the Almighty's revelations.

2. God, as manifested in his *providential* government, is properly exhibited to us in the imagery of the text. His ways are past finding out. When we contemplate the world at any particular period, we are lost in confusion and perplexity. We feel assured that the Almighty governs; but his purposes are hidden. Mankind seem scarcely to notice his presence. Seldom can we detect his controlling hand. It is only by extending our observation over a wider field, and taking in the grand sweep of providence through successive generations, that we attain to the clear conceptions of his moral government. At first view, we see little of his movements, and they are indefinite and obscured, like the dim smoking furnace passing by us; but by a more patient and careful study we are enabled to discover that all the events which take place in the world are under the Almighty's superintendence, and that, back of all the derangement and confusion of human affairs, there is an unseen but mighty hand bending the current of events, which by the interposition of checks and restraints and judgments makes the wrath of man to praise him.

Thus in the midst of all the darkness of providence, there is discoverable a plan of infinite wisdom. And he who humbly and devoutly meditates upon the progress of human events, detects the presence of the Almighty, ofttimes indeed vaguely, like the feeble glimmerings of the smoking furnace, but often distinctly and clearly, like the burning lamp. Thus does Jehovah, in his providence, move through the ages in much the same manner as he appeared to the patriarch, when the furnace and the lamp passed between the pieces of his sacrifice.

But why need we range abroad? Why look far away? Who that devoutly studies the ways of Providence towards himself, who that habitually contemplates what he has passed and is passing through, does not discover the Almighty wrapped in the same mysterious drapery which he wore when he appeared to Abram?

Yes; the smoking furnace and the burning lamp still pass before us, and shape our lives. How many times has God touched the hidden springs of action, and turned the current of our history! How often has he mysteriously hedged up our way, and disappointed us; made our surest calculations fail, our favorite plans miscarry! How has he led us by a way we knew not, and caused us to stand perplexed, bewildered, and alarmed at his unlooked-for interpositions! What sudden calamities have befallen us; what sore chastisements have come upon us! How many times has God's face been hid in clouds! How often have we asked, What can his doings mean? Why does he

scatter our possessions? Why is health prostrated, and we left to languish amid pains and sicknesses? Why did he let death make those little graves in the churchyard, where our darlings are sleeping, who used to fill our homes with sunshine, and paint rainbows in the clouds of life's pilgrimage? Oh how many times are we perplexed at the Almighty's doings! In such seasons of disappointment and affliction, we think upon God and are troubled. He passes before us in the thick gloom and darkness of the night of sorrow: about all we can see of him is a smoking furnace, with its smouldering embers, scarcely emitting from within a pale, faint, spectral gleam, while dim wreaths of clouds whirl and roll above it. God's ways seem dark and impenetrable. Such are our first impressions.

But while we continue to gaze upon his doings, and follow out his providences to their conclusions; when, after Time with his soothing balm has assuaged the first sharp pangs of our wounded hearts, we study carefully the tendencies and results of God's dispensations with us, Oh how often do the clouds break and scatter, and the deep mysteries of his dealings receive a new interpretation.

How many of our doubts and questions find an answer. How do future months and years vindicate the wisdom of those doings which we once thought could not be vindicated. How do we afterwards see that when God took away some blessings which we dearly loved, it was to make room for greater ones to come. When he stopped our way in some favorite

pursuit of life, and beckoned us against our will in another path, he saved us from ruin and disasters which we were blind to. When he snatched our loved one away to heaven, he broke up the sinful idolatry which was ensnaring us, and called us heavenward too. When he dashed from our hand the cup of worldly prosperity we were pressing to our lips, it was because we were growing delirious under its draughts.

It is thus, while we calmly trace through successive years God's doings, we begin to see the furnace grow luminous, and close behind it the burning lamp lights up the Almighty's footsteps. We may not indeed comprehend the whole. We cannot clear up all the mystery that surrounds him. But though the furnace still continues to move and smoke before us, yet the lamp is ever going with it; and its cheering rays relieve the gloom, so that faith and hope can follow.

Such is the method of God's dealings with us all. He passes before us in mingled mystery and light. The longer we trace his doings, the clearer is the light. A hasty, superficial study of his providence leaves us in painful gloom and doubt. But a patient and humble attention to his plans reveals much to relieve our fears and inspire in a Christian a steady, trusting, joyous confidence.

We must never expect to arrive at a full and undimmed prospect here. We see but in part. But ah, I think I can see something in the gradual unfoldings of God's providence, and in the steps the believer now

passes through, which heralds a coming period when we shall see the whole. Even now the shadows grow fainter the longer we gaze. A grey light streaks the field of vision which was once in total darkness. Even now, when faith turns her eye out long and steady, night seems softening into morning. And from these phenomena I expect yet to see the whole. Even now, while I watch year after year, the furnace smokes less and less, the lamp burns stronger, brighter. And a little way beyond me heaven waits to welcome me, where I shall see as I am seen, and know as I am known. Oh blessed hope!

A little longer we follow where the furnace and the lamp lead the way; but when we arrive at yonder world the furnace will be left behind. No cloud and smoke there to obstruct our vision; but the lamp of fire alone remains. It is God's unvailed glory illuminating the realms of bliss. Oh, weary pilgrim, keep close to the furnace as it moves before you like the pillar with which Jehovah led the twelve tribes in the desert, and it will guide you home. And then it will smoke no more; but the lamp of fire will never go out, for in its exhaustless splendor you shall spend an eternity of joy.

Our subject thus presented, furnishes materials for a few profitable reflections.

1. In this blending of mystery and light which characterizes God's present manifestations, he has in view the promotion of *his own glory*. For the pure and unfallen inhabitants of heaven, it may be proper for

him to unvail himself and his doings, and allow them to contemplate him in cloudless majesty; but when he turns himself to sinful creatures like us, it is becoming in him whom we have offended not to allow us to approach too near. A jealous reticence marks his revelations. His infinite glory and majesty impress our minds as deeply by what he hides from us, as by what he shows us. His silence is sometimes as awfully eloquent as his speech. The dim, smoking furnace often conveys to us ideas of his incomprehensible might and majesty and greatness as deeply as does the burning lamp.

2. The Most High has designed this obscure and mixed economy of his to be a source of *moral discipline* to us all.

It serves to check our arrogance and presumption, and promotes true humility. It teaches us that he has ways that are past our finding out, and that all our boasted wisdom is folly when compared with his. It tells vain man that he cannot tread in the Almighty's footsteps, nor fathom his deep designs.

Our entire dependence too is thrust upon our convictions by this mode of the Almighty's working. Often we are forced to feel that we cannot rely upon our own forecast and prudence. Our own will is not strong enough to shape events and make them subserve our wishes. God's unseen hand is ever interfering, and reminding us that without his blessing we can do nothing.

And how too is faith *tried and encouraged* by this economy: *tried* when all we can see of God, many times, is like a smoking furnace, dark and obscure, when reason asks and gets no answers; and anon encouraged, when through the mystery there shines the burning lamp.

This present life is the great school of Christian faith. Where reason's eyesight fails, faith can see the way. It can see but in part, it is true, for our earthly state answers well to the prophet Zechariah's description: "And it shall come to pass in that day, that the light shall not be clear nor dark. But it shall be one day which shall be known to the Lord: not day, nor night; but it shall come to pass that at evening time it shall be light."

Moreover, how adapted is our subject to *cheer* God's people and prompt them to quiet, patient resignation under dark and afflictive providences. What if sometimes we can see nothing but the furnace smoking; we know that behind it somewhere is the lamp of fire.

How too are we impressed with the truth that there is something left for us to learn *in heaven*, something yet unrevealed which we do not see, but which we hope for, which makes us reconciled to the thought of leaving this dim, misty realm of time, and to wait in anxious expectation till the day break and the shadows flee away. Oh be content, Christian, a little longer to walk by faith, for by and by the smoking

furnace will have passed away for ever, and heaven will welcome you to its cloudless revelations.

Learn to walk humbly before that God who surrounds your path. See him in the clearest form in which he has revealed himself, even in the incarnate Son our Saviour. Through him alone can we approach the Father. Through him alone can we hope to see his face, and obtain salvation and deliverance from his wrath.

X.

The Altar of Incense.

AND THOU SHALT MAKE AN ALTAR TO BURN INCENSE UPON. AND THOU SHALT PUT IT BEFORE THE VAIL THAT IS BY THE ARK OF THE TESTIMONY, BEFORE THE MERCY-SEAT THAT IS OVER THE TESTIMONY, WHERE I WILL MEET WITH THEE. Exod. 30:1, 6.

The saying of Augustine, that in the Old Testament the New is hidden, and in the New Testament the Old is opened up, agrees with the teachings of Paul in the epistle to the Hebrews, which declare that the rites and ceremonies of the Mosaic institute serve unto the example and shadows of heavenly things. This being so, the institutions of the ancient church of God are not obsolete and meaningless to us. Although their literal observance has ceased, still the profound and important truths of which they were the symbols survive—truths which shine forth unveiled in the clearer revelation of the gospel. These ancient symbols claim our careful study still; for they are helps to faith now, and serve to illustrate and enforce those didactic truths of the New Testament which, through the feebleness of our spiritual perceptions, often fail to impress us as they should.

Our attention is directed by the text to the altar of incense placed in the tabernacle which Moses constructed under the immediate direction of God.

The tabernacle was designed to be the local habitation of God, to bring him near to his covenant people, and to keep up a direct intercourse between him and them.

Through it God condescended to help the natural weakness of the human mind. In dealing with divine and spiritual things, the soul universally feels the need of help. It is lost in the infinity of God's nature. It longs for some definite apprehension of him, some nearer fellowship than it can enjoy in the conception of the great unseen and distant Jehovah. The pathetic desire of Job finds a deep response in every thoughtful soul: "Oh that I knew where I might find him, that I might come even to his seat."

The gospel dispensation satisfies this craving for some visible link to conduct our thoughts to God, by exhibiting to us God manifest in the flesh—the divine Word dwelling among us. But before Christ came no such aid appeared. God however gave to his ancient church the tabernacle, where he would dwell; thus bringing distinctly to their minds his presence in the midst of them. Here lies the spiritual significance of that sacred structure. It was God's dwelling-place among the people. It brought God near to them, holding converse with them, and approachable by them.

This sacred structure consisted of two distinct parts: the inner chamber, called the holy of holies, where Jehovah dwelt. There was the ark of the covenant, upon which rested the mercy-seat, and over which

hovered the two cherubim with extended wings. There the shechinah abode, the strange, unearthly sign of Jehovah's presence.

This hallowed apartment was hidden from the public gaze. No creature footstep dared to cross its threshold, save the high-priest, and he but once a year, on the great day of atonement. God indeed dwelt among his people, but it was in awful, mysterious, solitary grandeur, which allowed no rude familiarity, no irreverent approach.

The second apartment of the tabernacle was called the holy place, where the priests and Levites daily ministered; the furniture of which was the altar of incense, the table of show-bread, and the golden candlestick with its seven lamps. The vail separated this part from the holy of holies. Here the people appeared only by their representatives in the priestly office.

Surrounding the entire structure was the court, enclosed by curtains, where the Israelites assembled and brought their sacrificial offerings. In this court stood the altar of burnt-offerings. Here was the spot where the blood of the bullocks and of rams was shed; where the altar fires blazed; where the robed and mitred priest gathered the blood with which he entered the holy place. Here the penitents confessed their sins and sought for pardon. Here the grand scene was enacted which proclaimed continually that without the shedding of blood there was no remission.

Bear in mind this description of the several parts of the tabernacle and their design, while we approach immediately to THE ALTAR OF INCENSE and study the deep spiritual significancy which surrounds it.

Observe, that connected with this sacred structure there are but two altars.

The first one that confronts us when we would approach where God is, is the "altar of burnt-offerings," in the outer court. We gaze here upon the bloody sacrifices. Here are the touching scenes of suffering and death. Here are the types of the great atonement made in the passion and death of Jesus Christ. Here we are taught that if we would attempt to reach God's presence, we must first of all come to the blood of Christ. We must stand by the altar of burnt-offering. We must find the Lamb slain from the foundation of the world. There was no way into the holy of holies of the tabernacle but by that altar. There is now no way to God but through a dying Saviour.

Within and beyond this altar, in the holy place, stood the second altar, the altar of incense. What was the spiritual significance of this altar? On it no victims were slain, no blood was shed; but the priests daily burnt upon it incense, a preparation of pure frankincense and other sweet spices, which yielded a fragrant and refreshing odor.

The symbolical meaning of this incense-offering is plainly given us in the Scriptures. It is not propitiation or atonement; that is made already in the outer court; but it is the pure devotion of the saints—the prayers,

intercessions, and worship of God's true people. Thus David says, in the 141st Psalm, "Let my prayer be set forth before thee as incense, and the lifting up of my hands as the evening sacrifice." Here is a direct reference to the priests' burning incense on the altar every evening at the time of sacrifice, when they entered the holy place to light the lamps of the golden candlestick.

The prophet Malachi also describes the pure worship of the universal church of God by the same symbol: "For from the rising of the sun, even unto the going down of the same, my name shall be great among the Gentiles: and in every place incense shall be offered unto my name, and a pure offering; for my name shall be great among the heathen, saith the Lord of hosts." Again, in Luke 1:10, we read that when Zacharias the priest went into the temple to burn incense, the whole multitude of the people were praying without at the time of incense; that is, while they stood in the outer court and worshipped, the incense was burning in the holy place before the vail. But more impressive still is the scene which John witnessed in his vision of the heavenly world: "And another angel came and stood at the altar, having a golden censer: and there was given unto him much incense, that he should offer it with the prayers of all the saints upon the golden altar which was before the throne. And the smoke of the incense which came up with the prayers of the saints, ascended up before God out of the angel's hand." In chapter five he declares that the golden vials full of odors are the prayers of saints.

In these Scripture passages we have a clear explanation of this altar of incense standing in the holy place. The offering made upon it is not of blood; it is the fragrant breath of flowers, the odor of beauteous plants, exhaling their sweet and ravishing perfume from their own inner life, and filling the holy place with a refreshing vapor most delightful to the sense. This is God's chosen figure of the devotions and prayers of true believing hearts who approach near to him. These offerings of the heart are sweet to Jehovah as the balmy fragrance of choicest flowers. They are the soul's exhalations, the breathings of its spiritual life, the fervent aspirations of the renewed and sanctified spirit, as delightful to God as are the sweetest odors of the rarest plants and spices to the bodily sense.

Oh what a view do we get of God while we crowd around this incense altar. Now we can pray in earnest; now we can offer him our best and holiest affections; now we pour out our thanksgivings and confessions; for our worship rolls heavenward like the fragrant cloud of burning incense, and God above is pleased to accept it and to bless it.

But let us be careful what we call worship. Let us not forget that the incense of our prayers and devotion derives its perfume directly from the intercession of Christ, who, as our high-priest, has gone into the holiest before us with his blood. Without a living faith in him, a vital union with him, so that he intercedes not only *for*, but *in* us by his Holy Spirit, we cannot stand before this altar.

We have no incense. If there be any excellency in our prayers, or purity in our devotions, to insure their acceptance, it is because of his Spirit making intercession for us. We burn our incense before the mercy-seat, and the cloud rolls heavenward from the altar; but whatever fragrance it bears is derived from the cloud already there, the incense of the Saviour's intercession, with which it mingles and floats around the throne, breathing sweet odors before Jehovah's face.

We are standing in the holy place. Let us examine well the incense we presume to offer, for says Jehovah, "Ye shall offer no strange incense thereon, nor burnt-sacrifice, nor meat-offering: neither shall ye pour drink-offering thereon." Special directions were given, and special care was taken for the preparation of this incense of the tabernacle. It was associated with the deepest sacredness. The people were forbidden to use it upon any common occasion; the priests alone could burn it upon the altar.

Is it in the power of language to teach us more impressively than this incense-altar does, that we should come with the utmost care and preparation to present to God our prayers and worship? Think not that any thing and every thing you may bring as incense will be accepted. Vain will be your lip-service; vain your cold, heartless offerings. Strange incense it is you profess to burn when the soul still harbors its evil passions, when pride and worldliness and sensuality are cherished there. There may be the bowed head, and the bent knee, and the solemn

utterance of devotion; but God's immediate eye is on you, and will detect the emptiness of all your service. Such service is a profanation of the holy place. Such incense only provokes the Most High to anger. Beware lest the fire you kindle to burn it with break forth upon you and consume you, for says Jehovah, "Ye shall offer no strange incense" upon my altar. What then must be the state of our hearts in order that we may bring a pure offering of incense before God? What is necessary to acceptable prayer and worship?

To answer this, come once more by the altar and examine its position. It stands in the holy place of the tabernacle. To reach it the worshipper must come through the outer court—must pass the altar of burnt-offering. There he learns that there is no access to God except by blood. There he learns of atonement through the sacrifice of Christ. There he stands as a sinner who needs an expiation. There he makes his confession, and lays his hand upon the head of the sacrificial victim. He can get to the incense-altar only after he has stood there and found a propitiation for his sins.

Learn then, that if you would assay to approach God, you must come first of all to the cross. You must find an atonement for your sins through the Lamb of God. There is no other way of access to him but by faith in the blood of Jesus. Come first to Calvary, and gaze upon the great propitiation, the Victim dying amid the altar-fires of divine justice. Come as a sinner, for pardon and purification. Come with his blood

sprinkled upon you, with faith in his merits only, or else you cannot gain access to God.

2. The altar of incense stood very near the holy of holies, the immediate dwelling-place of God. "And thou shalt put it before the vail that is by the ark of the testimony, before the mercy-seat that is over the testimony, where I will meet with thee." To burn our incense upon this altar we must come very near to the mercy-seat, to the vail, to the holy of holies. Faith in the merits of a Redeemer emboldens us to take this place. It is most holy ground we stand on when we offer our praises and prayers upon this altar. We are close to God. The incense-cloud ascends, and penetrates the inner sanctuary. We gain a fellowship and communion with God. Faith brings us to cordial intimacy with God. Such is the nature of that acceptable worship which was so vividly symbolized by the burning incense in the holy place before the mercy-seat.

3. But it is worthy of remark that near as was this altar to the Shechinah and the cherubim, the vail still hung between. Near as we draw to God in prayer and worship, he is still invisible to sense. Christ, our great Intercessor, has entered within the vail. Our vision cannot follow him, whom not having seen we love. We cannot yet gaze upon the immediate glory; we cannot yet approach the throne. The vail hangs before us, and "we walk by faith, not by sight." We stand with holy reverence, and bring the incense of our hearts upon the altar; but we dare not attempt to look within. Faith stops there, waiting at times to catch the

whisperings of grace from off the mercy-seat, and to hear the rustling of the vail. "There will I meet with thee," says God. There the true worshipper will hear the answers to his prayers; there will the soul find peace and blessedness.

Such are some of the great truths symbolically taught in this department of the Jewish tabernacle. Nor can it be said that the pious Israelites did not understand them. They read the impressive lessons; they saw the meaning of those rites; they looked beyond the outward and the sensible. I verily believe they had a quicker discernment of the deep spiritual meaning of God's ancient ritual service than many so-called Christians who boast of gospel light and privileges. Yes; it might be well for many to go to school to Old Testament believers to revive their piety, to follow the ancient priest through the solemnities of the tabernacle service, and learn from the sweet singer of Israel the spirit of devotion.

What a view does this subject give us of what true worship is. It is the incense of the soul rising up to heaven like a perfumed cloud. It is near fellowship of the heart with God. The prayers and confessions, the supplications and thanksgivings of the saint bring him close to the mercy-seat. Nothing but the vail hangs between him and God. "There will I meet with thee," saith Jehovah. This is the Old Testament view of true devotion. Oh how far beyond the cold and distant formalism, the hackneyed routine of many Sabbath services of these New Testament times. Oh was not God nearer in thought to many a pious Jew

standing in the tabernacle court, than he is to multitudes in our gospel sanctuaries, who gather there, not to meet with God and tremble and rejoice in his felt presence, but only to listen to a creature worm, and find entertainment in the eloquence of the preacher?

Again, how strait appears the way of access to God. How carefully must we approach him. Many seem to think that God is easily accessible, and that they can come to him at any time and in any way they please; that little or no preparation is needed to gain his favor; that the sinner in the hour of sudden alarm can cry for mercy and be saved; that the dying reprobate may mutter a prayer and go to heaven; that the heartless formalist may read his collects and please God; that no matter what may be the creed or life, God may be found whenever the sinner wishes for him; that all may seek and find him in the way they please, and one way is as good as another. Such are the loose notions many entertain of gaining heaven.

But our subject scatters them like the chaff of the threshing-floor. The holy of holies, where God waits to meet with us, is not reached in any way we please. The heart's incense must be carried within the holy place before it can be offered. There stands the only altar on which it can be burned. But to get there we must first find an atonement at the altar of burnt-offering in the outer court. There is no getting near to God but through the blood of Christ. There is no salvation in any other name. Only as a sinner, contrite and believing in a dying Jesus, can you find God. Go,

stand by the cross: there, with deep repentance and humble faith, seek for an interest in the pardoning blood of the Son of God, and then may you pass through to the holy place, and pray and praise and worship. But without first coming to the atonement of Jesus Christ, all your pretended regard for God is mockery; your religious service is but strange incense, which God abhors.

Before we close, let us lift our eyes upward from these patterns of heavenly things to the heavenly things themselves. For in heaven, John tells us, he saw the golden altar, and the angel with the incense-censer before the throne. This incense-offering is the prayers of saints. In that world of blessedness the altar stands without the vail before the throne of God. There the redeemed worship face to face; there they gaze upon the Godhead, and cast their crowns at the feet of Jesus. Faith gives way to vision, and they behold the face of God in righteousness. Oh what a prospect lies before the saint. Are we preparing for such a service? Do we expect to join in the worship before the throne? How diligent should we be to cultivate a spirit of devotion while in this tabernacle below. Though we are now outside the vail, how should we strive by faith to meet with God, and find answers to our prayers. What a solemn hour should this be to us in the sanctuary, when we appear before the mercy-seat and offer the incense of our prayers and thanksgivings.

XI.

Eating under the Juniper-Tree.

ARISE AND EAT; BECAUSE THE JOURNEY IS TOO GREAT FOR THEE. 1 Kings 19:7.

These words, though originally spoken to the prophet of God under peculiar circumstances, may still have a meaning when applied to the believer. Though written aforetime, they were written for our instruction when we are brought into straits and trials.

They came to the prophet in one of the darkest hours of his ministry. Though he had gone through Samaria with signs and wonders, and though he had signally triumphed over the prophets of Baal, and had witnessed their destruction, still the reformation of the nation which he had looked for seemed further off than ever. All the miracles he had wrought, and all the teachings he had uttered, seemed to be worse than in vain; for now, instead of submission, there is nothing but exasperation, and the abandoned Jezebel swears vengeance upon the prophet. He despairs of the redemption of Israel, and turns his back in flight from Samaria. Without any special divine direction, he wanders over into the territories of Judah as far as Beersheba. But there is no rest for his troubled and dejected mind; and he flies from the haunts of men and plunges onward and onward into the wilderness towards Horeb, as though, in the savage wildness and

solitude of nature, he would find sympathy with the desolation that reigned within him.

But night overtakes the wanderer, and he is forced to halt and lie down under the protection of a juniper-tree. There his troubled thoughts dwell upon the past, and he revolves in his mind the complete failure of his mission to Samaria, the miracles which he had wrought, and the vengeance which was pursuing him. All was lost. 'Twas useless to undertake to preach more or to labor more for that idolatrous people. Disappointment has crowned his every exertion, and not a ray of hope shines from the future, to call back the request of the Tishbite that he may die. In his despair and anguish he mutters, "It is enough; now, O Lord, take away my life."

He sleeps. But one of the ministering spirits is at his side, in this hour of desperate extremity. The prophet, at his touch, starts up and eats. The gnawings of hunger being partially allayed, he again sinks down to sleep, till again the angel touches him, and bids him eat the more; for he is not to die yet. He has not yet done his work; he must tread the wild crags of Horeb, and back to Ahab and Samaria, once more. "Arise and eat; for the journey is too great for thee."

We must have a poor faculty of apprehending spiritual lessons, if we allow this narrative to pass without some practical instruction.

We do not tax our imagination severely in order to see, in the person of Elijah, a representation of the child of God in seasons of depression and despair.

Not unfrequently is he brought into the position of the prophet. Not at all times is he privileged to stand upon Zion, and to rejoice in hope. But a thousand circumstances in life conspire to disappoint his hopes and becloud his prospects, till he flees from his post, and is found far away under the juniper-tree in the wilderness.

When the sanguine expectations which he indulged at the beginning of his discipleship, become one by one disappointed; when he finds that Christian experience is a far different affair from what he had conceived of; when straits and trials spring up around him at every turn of life, such as he had not counted on, and the work of grace in his heart seems, after all, to amount to nothing; when new and unlooked-for symptoms of corruption are daily brought to light, and the ardor of his first love is dampened by the checks and crosses that thicken around him — when thus his early dreams are dissipated, and his heart feels a sickness and a faintness come over it, do you not see that he is in the wilderness? Oh who has not sickened at the slow work of grace within him? Who has not marked the sad contrast between what he once said he would be, and what he is; and who has not felt the harassments of doubt and the vanity of his own strugglings, till he despaired of success, and fled like the prophet to the wilderness?

And then ofttimes the little good which the Christian accomplishes in the world is enough to drive him to dejection. The Tishbite fled because he saw no good from all his labors. Doubtless he had expected that,

with the support of miracles, he should soon have worked a reformation in Israel. But though at his word the heavens had been shut up, and though at his prayer the fire of God had descended to attest his mission, still the whole outlay of means seemed to end in nothing. His expectations had not been met; and under the burden of the keenest mortification, the most hopeless dejection, he lies down by the juniper-tree and prays for death. Have you never lain there with him, Christian?

When cast down in spirit, in view of your personal infirmities, you have asked for the good you have done in the world around you; when your efforts for Christ seem all to prove abortive; when your kindly warnings are disregarded, and in spite of your prayers and solicitude, iniquity abounds, and none turn to the Lord; when the more you strive for the Redeemer, the more your good is evil spoken of; when the wicked around you seem growing worse and worse, and disappointment and unbelief becloud your heart, and you see no hope, and the wilderness is around you—Oh, when thus the heart droops, do you not feel that you are in the wilderness? 'Tis indeed a dreary situation. But in life's pilgrimage, the Christian sometimes journeys that way. He has his hours of sadness, of heart-sickness, of deep despondency and dejection, of bitterness which a stranger intermeddleth not with. He is at times left to experience the burdens of life, the faintings of faith and hope—to feel that notwithstanding his long trial of the Christian life, all is jeoparded, and that nothing remains for him but to cast himself down with the

fugitive prophet under the juniper-tree, and say, "It is enough; now, O Lord, take away my life."

But what we would observe is this: that the Saviour has provisions for his children however desolate may be their condition. It was in this dreary extremity of the prophet, that God revealed unto him his presence. Worn out with hunger and fatigue, despairing of hope, and feeling even life itself to be a burden, the fugitive drops to sleep. And now God, by a miracle, comes to his rescue. A cake baken on the coals is beside him, and the cruse of water, to refresh him and keep him from destruction. Here God came to his prophet and revived his confidence. Here he gives him a token that he has not given him up, but sends his Angel to rouse him from his dejection and bid him eat.

Not to the prophet alone has God manifested his presence and aid, but to all his dear children as they sit and sigh under the tree where the prophet slept. Not that, when we are cast down and desolate, we actually feel a hand touching us, and see before us the cruse of water and the cake upon the coals; but we find the same deliverance, and the rustic table is virtually set before us and served by a spirit hand. In the appointed means of grace we find the aliment that sustains our souls. The divine ordinances seem to us more precious than ever while we sit under the juniper-tree. In the sweet promises of the word of God, in the dawn of Sabbath hours, in the tender and timely lessons of the sanctuary, in the Bethel seasons of prayer, in these means afforded to us, we find the

cruse of water and the cake that will refresh us. We may lightly esteem them in a time of ease and plenty; we may think little of a cruse of water and a cake when we repose in abundance; but in the wilderness, when hunger and faintness come over us, and the juniper boughs are our only covering, then they are as sweet to us as to the weary Tishbite.

When spiritual famine is gnawing at our hearts, and all is desolate and forsaken around us; when sickness has prostrated us, or death has cut down our companions around us, till the world seems empty, and a hue of decay and death tinges all the objects which we look at; when darkness and disappointment and disaster all weigh upon our spirits, and God is all that is left to us—how should we live were it not for the cake and the water cruse? How do we grasp the very means which we before had too often slighted.

We call up the neglected promises, and there is life in them. Our troubled thoughts find vent in earnest prayer; and whether we lie stretched on the bed of languishing, or wrestle in the closet, or meditate in the sanctuary, we find the water cruse is beside us, and we are kept from fainting. Oh, it is when, under the load of crushing sorrow and dejection, the wanderer sinks down by the shrub of the desert, it is then he prizes the cruse and the cake. Many of you, I doubt not, were you to call to mind the season when you valued most the presence of the Master, when you wrestled nearest the mercy-seat and experienced the most surprising deliverances, would point to the days of sore trial and weariness, when you gave up

all hope, and when, turned out from the world, you sat alone and sighed under the juniper and waited for death. There you fed upon the bread of life. And though you felt that you were pilgrims in the desert, you still felt that you were not forsaken.

But, brethren, we need not only the provisions made for us in the means of grace, but we need also a friendly hand to help us to partake of them. We need our attention called to them with a voice that can reach the inner ear; for too often, with all our distress and dejection, there comes also a lethargy and insensibility which, if unbroken, must at last prove fatal. The care-worn prophet, with all his wretchedness and despair, still reclined his head and slept. Hungry and weak and way-worn, a drowsiness nevertheless came over him, and he must needs be aroused if he was to be strengthened. The cake is there, and the cruse of water is there, and the coals are glowing, but the pilgrim heeds them not. What a figure is this of the complaining and dejected Christian who is starving for the spiritual food that is beside him, and at the same time sleeping in his sorrow. Despondency and unbelief have so paralyzed his heart that he takes no nourishment, even though the promises and the Sabbath and the sanctuary are before him; but they are dead to him, they are useless to us all, so long as we sleep on.

But beside the man of God, as he lay and slept under the juniper-tree, there was not only the cake and the water cruse, but the Angel too. And here, in the touch and the call of the Angel, methinks I discover a most

beautiful emblem of the Holy Spirit standing by the means of grace, and bidding the believer *"arise and eat."* The presence of that ministering spirit was necessary to the prophet's preservation. Without his friendly touch, he would doubtless have slept on, and death closed the scene ere the day dawned, and the cruse of water and the cake have been in vain.

Thus too we need a present Spirit to rouse us to partake of the blessings that are brought to us; for though we may complain of want, we are too indifferent to the supplies afforded us. Though we feel that we are pilgrims in the desert, though we sigh and faint by the juniper boughs, we sleep there too. Our eyes are heavy, and we do not see the water cruse, though it is at our side. We do not appreciate our privileges, nor draw nourishment from them. They may all be at hand—the Sabbath with its sacredness, the Bible with its promises, the sanctuary with its lessons, the mercy-seat with its covenant—but not till the Holy Ghost shall bid you arise and eat, will these means avail you aught.

That Spirit is sent out to accompany the means of grace. He bids you arise and eat. He comes to rouse you from your slumbers. He comes to stop your murmurs. He comes to point you to the provisions at your side, and bid you rise and eat. Eat of these means of grace; use them to revive your fainting spirit, to increase your strength. Though you may have used them many a time before, still you are called upon to eat and eat again. The Spirit and the bride say, Come.

We would second the Spirit's voice, and call to you in the wilderness to arise and eat. It becomes you to-day to heed the call. There is reason for the Spirit's rousing you, for you are yet away from home, and the journey is too great for you. Perhaps you may feel no pressing need. Perhaps, like the Tishbite, you have tasted a little, and you would lie down to sleep. But the prophet knew not what was before him, as the Angel did; and hence he is again aroused with the warning, "The journey is too great for thee." Christian, you know not what awaits you. You need these ordinances. You need this Lord's table spread before you. You need these means of grace, for you are in the wilderness, and the desert must be crossed. Your strength and patience will be sorely tried, and your provisions will be short. Arise and eat, for you will have no other supply but this. You must take up with a pilgrim's fare. The remainder of life's journey is before you, and it will be too great for you unless you prepare in time.

You may stand aloof from this our table, and despise our humble ministrations as though they were not good enough for you. We do not pretend that our supper is equal to the one above. We can give you but travellers' fare, but such as it is it will sustain you on your journey. Our entertainment to-day is as simple as the prophet's rude meal which he ate beneath the juniper-tree; but remember, that but for that water cruse and baken cake he would have perished in the lonely solitudes. And we lay as high a claim for the gospel institutions to-day. Without them you must faint and die. Underrate them as you will, God has

appointed them to sustain his children in the desert. Your neglect of them will be followed by exhaustion, for "the journey is too great for thee."

We cannot indeed anticipate the circumstantial history of any one of you. We cannot trace out in the wild desert sands the pathway over which each one of you must wander. No, we cannot discover where one of us will be to-morrow. Our experiences may be far different from each other. We shall each have our peculiar difficulties, and no two of us will travel with the same footstep and the same burden.

But though we cannot tell the future to a single one of you, though we cannot calculate your reckoning at all, still we can assure you that "the journey is too great for you." We shall all of us need the cruse of water and the cake ere we get through, for we have no abiding place here. There will doubtless be many days when this world will look more desolate than ever, days of temptation and of conflict. The adversary will doubtless harass your wanderings, and hedge up your way; you must yet fight "the world, the flesh, and the devil."

Again and again will you be obliged to retrace your wayward steps, and water your path with the tears of bitter repentance and regrets. Again and again will the world so bedim your eyesight and bewilder your thoughts that you shall have lost sight of heaven and plunged in its vanities. And the heart-work too is not yet all done. You must yet keep up the warfare with

corruption. You must yet keep up the struggle of grace and fight the fight of faith.

"The journey is too great for you." There may be years of conflict yet before you. There may be fiery trials in reserve. Light as may seem the enterprise now, you will find it great enough before you get to heaven. 'Twill seem great when sorrow and disappointment shall gather round us, and when the hours of fierce temptation give way only to the hours of deepest darkness; 'twill seem long when the cross seems ever to stand by the roadside, and when year after year we get no clearer views of heaven, our home.

Great is the journey; and we shall feel it so when onward and onward we travel, and our companions one by one drop at our side, till we are left to tread our way alone. 'Twill be great when the dependencies of life fail, and the calamities of life shall thicken around us. When the hopes of earth shall wither, and the friendships of earth shall vanish; when the past shall appear as vanity, and the heart shall recoil from the future; when fathers and mothers, and brothers and sisters, and all the loved ones of our early days, shall have vanished from our sight, and no long familiar voice shall speak to us in the solitudes of earth's wilderness; then, as we stagger on, with our staff trembling in our hand, shall we feel that the journey is too great for us.

You may say that it will be short to some of us; that even now the sandals are loosening and the city is

coming nearer. Yes, some of us will not journey long. But short as may be that journey, it is too great for you. For remember how it winds up with the death-groan, the faintness, the weakness, the sinking, the dimness, the muffled farewell. Great journey this through the dark valley and through the wild surges—*too great* for us. We cannot explore the pathway; 'tis dark and dubious. We have seen multitudes set foot upon it, and they all turned pale. The pilgrims have not come back to us to tell us of it, but we know enough about it to know that the journey is "too great for us."

Yet, brethren, we are all hurrying thitherward. Are we strong enough? What shall sustain us in the desert? Behold, God has supplied us with his gifts. Behold, ye who are desponding, ye who are wayworn, ye who are despairing beneath the juniper-tree, the cruse of water is beside you. Rise and eat, for the journey is too great for you. Oh, who of us will not gladly come?

What should we do without these blessed ordinances and precious privileges? To-day the Master spreads our table in the wilderness. Once more he would refresh our hearts and lend vigor to our graces. He meets us with the tokens of his love. Come, beloved, and meet the Master. Come from your murmurings at the waters of Meribah. Come from your drowsiness and despondency beneath the juniper. Arise and eat, for the wilderness is yet before you. Take the cruse of water and the cake to-day, for it may be long before you have another opportunity. Supplies in the desert

are at best precarious; and so uncertain is our pilgrimage, that we know not that we shall meet again.

Have we full strength for the onward advancement? Would not a look at the Master profit us? Would not a friendly seat by the side of our fellow-pilgrims, and a kind look and a mutual, fervent prayer encourage us? Or are we equal to the journey without all this? Beware, my Christian friend, how you neglect the gospel means which are given you. Beware how you turn a cold shoulder to the simple cruse of water which God sends down to you, for he tells you that the journey is too great for you.

XII.

The Other Side.

LET US PASS OVER UNTO THE OTHER SIDE. Mark 4:35.

The facts and incidents in the history of our blessed Lord which the Holy Ghost has seen fit to preserve and hand down to us through the evangelists, furnish us materials for instruction and profitable meditation. The gospel is not all didactic; nor need the religious discourse be wholly such. It is well at times to omit the carefully framed propositions of a systematic theology, and dwell upon the simple narratives of the New Testament not merely as naked facts, but as pleasing allegories, or reflections of spiritual things. May we not read this narrative with such a purpose? As we follow the disciples in their night expedition across the sea of Galilee, may we not have suggested to our minds the Christian's course through the voyage of life towards the distant, unseen shore of eternity? Let us carry this idea with us while we study the parts of this simple, but graphic narrative of the evangelist.

1. It was *at the call and command of Christ* the disciples embarked upon their expedition. "Let us pass over unto the other side." There is no intimation that they had planned the journey, or had thought of leaving Capernaum before; but they took their departure solely in obedience to the direction of their Master. They acknowledged his authority; they trusted in his

wisdom. Their faith and confidence in him prompted them to do his bidding; and without questioning the reasons of his orders, they at once loosed from the harbor and set their sails, outward bound, for the other side.

It is even so with the believer when he forsakes the world of sin and vanity, and sets out on a Christian life. He hears a call from God, like that which Abraham heard when he left his country and his kinsmen for another land which God would show him. The invitations and commands of Christ prompt him to give up the world. Were it not for such a call he would live and die in his natural state of sin. No inward promptings of his own; no feelings of dissatisfaction with his present condition; no mere natural longings and aspirations, however deep felt, would move him to an earnest outlook beyond the present vanity, and to a heartfelt separation from the seen and the temporal which is around him. But when the external call of the gospel is attended by the internal call of the Holy Spirit, he feels a quickening power; he hears and obeys the divine command. Faith in the Redeemer leads him to obedience. He quits the world; he tears himself away from its deceitful charms, and consents to follow Christ.

2. I speak of their destination as expressed in the command of the Master. It was, "*The other side.*" They set sail, not for a short excursion along the coast, or an evening trip off from the mainland, and then to return; but across the sea to another country and a different shore. The words of the Master point

onward, onward beyond the billows to the far-off land. To "the other side" is the sailing order by which the disciples set their helm and trim their sail; to "the other side" they point while they loose from their moorings at Capernaum, and say good-by to the fishermen left behind upon the beach.

And is there not another side to our existence than the one we are now on? Is there not some shining shore beyond this one—beyond the billows, beyond the cloud-banks; something, if not discernible by our sense vision, at least discoverable by faith?

This side is familiar enough to us. We have trodden it and explored it; we know its features—a state of sin and disappointment, of temptations and illusions, a thousand vanities and shams; life ofttimes seeming a chaos of contradictions, pleasures glittering, syrens singing, sorrows brooding, hopes decaying.

"*This side*" where we are is a strange side, a dim, dubious shore, where tides ebb and flow we know not how; where the mirage plays upon our vision, and fills the atmosphere with phantoms which seem to us realities; where we seek for happiness in vain, till death removes us from the fitful, toilsome scene.

But is this all? Is there not another side, a different state, a better life to look to? The Christian who has heard the call of Christ has learned of another side than this one, another life besides the present. The call of Christ to him is to *the other side*. It directs him not to the things seen and temporal, but to the unseen and eternal. It points him far over the sea of life to the

distant shore, the other and the better country. This is the Christian's destination. For this he sails when he cuts loose from the world of sense and sin. Faith catches glimpses of its glories; for it is "the substance of things hoped for, the evidence of things not seen." For this he lives in expectation; for this he parts with sinful pleasures, and waits with patience till it comes. So long as he hears the Saviour's voice saying, "*To yonder shore,*" he can content himself with being a stranger here. Oh it is this "looking for a better country" that sustains him in temptations now. How cheering is the prospect!

When, Christian, you are troubled on every side here, how refreshing the Master's words, To "the other side." Yes; the pious heart often exclaims, Blessed be God, there is the other side, far different from this side; a future unlike the present; a heavenly land, whose scenery and surroundings are not those of earth. That other side is what you live for, Christian. Oh forget it not when tempted here; remember it, my brother voyager, when you hear the music along these shores of time, and would steer towards the havens of carnal ease and lie becalmed among the spice islands of worldly indolence and pleasure; remember, when the Saviour called you to a Christian life, he pointed far away and said, To "*the other side.*"

3. The time of their departure. "When the even was come, Jesus said unto them, Let us pass over unto the other side." The din and turmoil of the day were past; shadows thickened; the world was growing dark; the curtain of night was silently overspreading the land

and the sea: it was time to embark for the other side. And is not this suggestive of the circumstances under which the Christian enters upon a Christian life and sets out for heaven?

Oh if the present life had no shadows, we should never look beyond it; if this side was always bright, we should care little for the other. But it is a part of our heavenly Father's discipline, to visit us with trials and disappointments to wean us from this world. Ofttimes the sun of our prosperity goes suddenly down at noon; worldly plans miscarry; sickness preys upon us; friends die, and families are broken up; the world don't seem so bright as it used to be: this side gathers gloom and shadows. Then it is the soul is more open to the call of Christ; then it is, often, that the sinner is brought to forsake the world, and obey the voice of the Master saying, "Pass over unto the other side." It is at evening, when this world is growing dark, that the believer obeys the command of Christ, tears himself away from his sinful lusts with bitter, repenting tears, and exchanging sight for faith, embarks on his voyage to the distant heavenly shore.

It is evening; for although there be no temporal calamities sore pressing you when you become a Christian, it is still a time when the world has lost its sunlight to your soul, and when eternal things have flung their shadows over the heart and made every thing on these shores of time look dim and fading. Then we are ready for Christ. Then, when conscience is aroused, and the overhanging clouds of divine justice darken this side and alarm us, then we set out

for heaven, and heed the invitation of the Saviour which beckons us to the other side. It is at such a time the believer enters on a Christian life.

4. We follow him on his voyage to the other side, and notice the important fact that *Christ's presence* is with his people through all their way. Standing on the seaside at Capernaum, he sent not the disciples away alone. His word to them was not, "*Go yonder;*" but stepping on board their vessel, he says, "Let *us* pass over unto the other side." He himself will share their fortunes; he will go with them; though night be setting in, and dangers hover on the deep, they shall not go alone. No more shall the Christian. "Lo, I am with you always," is the blessed assurance of his Saviour. The presence of Christ is the great source of a Christian life.

This is all the saint can depend upon; this is what the gospel promises to him. Christ is said to dwell in his disciples—to abide with them. His divine influences are their only guarantee of safety. As well might the mariner be far at sea in a night of tempests, without helm or chart or compass, as the Christian attempt to navigate the troubled waters of life without the Saviour with him.

Better not *attempt* the voyage than start out alone for the other side. If you would leave these shores of sin and worldliness at all, see to it, first of all, that Jesus is with you in the ship, and that it is *his* voice alone you hear, as you set sail, saying, "Let us pass over unto the other side."

Once more, in the night voyage of the disciples over the sea of Galilee I see shadowed forth the changing phases of a Christian life. As they cast off from Capernaum, the evening breezes gently pressed their sails; the silvery ripples murmured on the shore; their little ship moved smoothly out at sea. The disciples sit in the cool evening air on deck, and watch the stars which, one by one, light up the vault above them as the shadows deepen and the shores grow dim. They have hardly missed their Master. They scarcely noticed that he had retired from their presence. But as the night wore on, alarmed at the dangers which surrounded them, the affrighted disciples look around for their absent Lord; and finding him asleep, they waken him with their cries for help. The Saviour, calmly rising from his pillow, looks out upon the angry elements, and speaks the word of power: "*Peace, be still.*" And the mad winds cease their roar, and the wild waves lie down to rest.

"'Ye waves,' he whispered, 'peace, be still.' They calmed like a pardoned breast."

Once more propitious breezes waft them onward, till the morning dawn slowly glimmers in the eastern sky, and reveals, in dim outline, the mountain summits of the other side.

In all this I think I see something which reflects the lights and shades of a true Christian life. How does the believer at his conversion set out for heaven with the consciousness that Christ is with him. How, after the throes of conviction are past, does he expatiate in

the sweet peace of believing, and rejoice in hope of the glory of God. How little dreams the convert of coming danger. How propitious the opening of his voyage. Often is his course so quiet that he suspends his watch, and loses sight of the near presence of Christ. Seasons come when he grows negligent, and perhaps feels no more of Christ's near presence with him than the disciples on the sea thought of their sleeping Master. Christ is not gone from him; but his ardent love towards Him has abated, and he no longer has that felt consciousness of His value he once had, nor does he realize his dependence as he should.

Trials come; temptations thicken; doubts and fears arise; Satan harasses him, and inward corruptions start into life again. Then is the soul tossed, like the disciples on the sea; then does the struggling believer look round for his Saviour, and cry, "Save, Lord, or I perish." Such trials of our faith come in the regular course of a Christian towards the other side, like the storm-belts near the tropics which lie in the sailor's route from one hemisphere to the other, and through which he must steer his way.

You and I, Christian, have sailed in such latitudes, and heard the winds of temptation blow, and felt the waves of distress dash over our frail bark. Thus we learned our weakness; thus were we humbled; thus were we taught to watch and pray; thus did we fly to Christ, and cry, "Lord, carest thou not that we perish?"

And it was his voice alone that stilled the tempest, and hushed the conflict of the soul. How sweet the peace of the believer after seasons of sore spiritual temptations! Great is the peace felt in the new-born soul when first it hears the voice of forgiveness; but there are other scenes, subsequent experiences, when, after fierce contests with lusts and passions, the Saviour gives the victory. Then when it is over there is a deeper tranquillity in the soul than was ever felt before. Then when we have weathered out the rough gales, and the heart has become sanctified and humbled, and we have got as it were out of sight of land on this side, then do we reach a clearer atmosphere, and enjoy the refreshing gales of the Spirit, which, like the trade-winds, bear us steadily along to port.

It appears that the disciples' expedition over the sea of Galilee was propitious in its beginning and at its close: their troubles lay along the middle passage. We may remark how this is generally the case with the Christian's voyage to heaven. Generally his latter course is tranquil as he draws near to the other side. Ofttimes indeed he catches glimpses of the shining shore, and on the sunlit hills beyond descries something like the domes and turrets of the celestial city. Ofttimes when well over towards the other side faith brightens almost into vision; he seems to hear the distant music, and grows impatient to step ashore. We watch his dying pillow till his heaving breast lies still. He has reached his eternal home; he has passed over unto the other side.

I have thus endeavored to employ the narrative of the evangelist to illustrate some of the prominent features of a Christian's life. He leaves the world of sin and vanity in obedience to the effectual call of the Holy Spirit. His destination is the better country on the other side. The Master who called him goes with him all the way, delivers him from the trials and dangers which beset him, and guides him over the sea of life to the heavenly shore.

How does this description compare with your own experience? Have you truly obeyed the call of Christ, and embarked for the other side? While the sailing order of our text is before you, it is a good time to heave the lead, and take an observation. On what course are you sailing, and what progress are you making in your voyage? Ah, may we not ask some who professed once to leave all for Christ, whether after all the stir and preparation of your setting sail you have not put back into the old port you set out from? Are you not still living in your sins?

Others may not have travelled far, though it be months or years since you started. Alas, there are not a few professing Christians who seem never to lose sight of land this side. Years may have fled, but they have not got many leagues at sea yet. Clinging to earthly things; in love with the pleasures, fashions, and follies of this life; hankering for wealth or position, they do little else than hug these shores of vanity, and coast along among the green isles of temptation which are near them. Heave the lead, my brother, and see where you are. The Master's orders

are, "*To the other side.*" And if you have been loitering in these waters of worldliness and carnality, it becomes you, by repentance, prayer, and self-denial, to change your course and steer straight for heaven.

Others in the heavenly voyage may have reached the storm-belts, where dangers threaten and skies grow dark. The waves of affliction dash over the soul; doubts and misgivings trouble you; crosses and discouragements beset your way, and often you tremble lest you be a castaway: but courage, my brother; if *Christ* be with you, you need not fear. Call to Jesus in the storm, and you shall ride it out. Think not that you have lost your course. If Christ be in the ship, if the soul has found him near, then head right to the wind and keep your course for heaven. "These light afflictions, which are but for a moment, work out for us an exceeding and eternal weight of glory."

And, my aged friends, may I not describe you as well-nigh over the sea of life, and nearing the other shore? Tell us, ye weather-beaten saints, have you not got through the rough middle passage, and heard the voice of Jesus say to the storms, "Peace, be still?" Scores of years have passed since you embarked with Christ; the world has changed, you have changed, and you are evidently nearing port: tell us, do you not feel that the night is far spent, and the day is at hand? Is not Christ nearer and nearer to you by faith, and do you not hope to be with him soon in glory?

Christian, don't you sometimes see land on the other side? Are not the hills of Beulah in the distance, and

the celestial gates? Oh tell us, as you near the other side does not faith catch glimpses of the redeemed and the Redeemer? Christian, you are almost home. Death will soon furl the sail, and moor you by the shore.

My impenitent friend, the call of the gospel comes to you substantially in our text to "pass over unto the other side." Oh when will you give up this world, and live for heaven? Though you may refuse to obey the call, you cannot stay here long. Life has another side, and you must, ere long, depart. There is an eternity to which you are going—a dim, dark, dismal shore, on which you will be cast at death, far off from heaven.

www.ingramcontent.com/pod-product-compliance
Lightning Source LLC
Chambersburg PA
CBHW051524170526
45165CB00002B/603